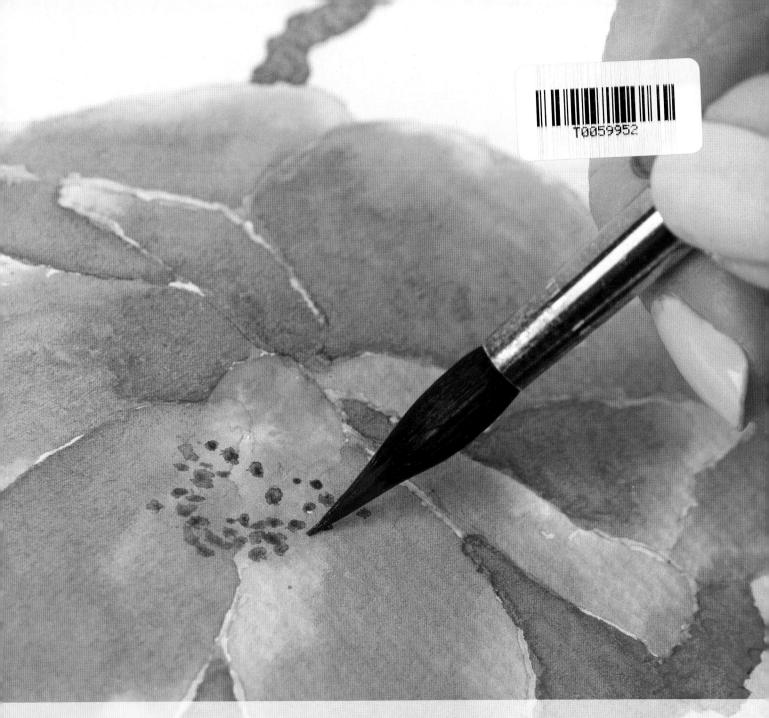

Watercolour
Flowers for the
Absolute Beginner

T0059952

'Start wherever you are and start small.' *Rita Bailey*

If you have something you want to achieve, don't let the size of your task overwhelm you. Break it down into smaller achievable chunks and give all of your attention and energy to each single task before you.

Watercolour Flowers for the Absolute Beginner

FIONA PEART

Search Press

First published in 2023

Search Press Limited, Wellwood, North Farm Road,
Tunbridge Wells, Kent TN2 3DR

Illustrations and text copyright © Fiona Peart 2023

Photographs by Mark Davison at Search Press studios, except
for pages 34, 54, 72, 85, 86, 96 and 118, author's own

Photographs and design copyright © Search Press Ltd 2023

All rights reserved. No part of this book, text, photographs or
illustrations may be reproduced or transmitted in any form
or by any means by print, photoprint, microfilm, microfiche,
photocopier, video, internet or in any way known or as yet
unknown, or stored in a retrieval system, without written
permission obtained beforehand from Search Press.
Printed in China.

ISBN: 978-1-80092-014-9
ebook ISBN: 978-1-80093-004-9

Publishers' note
The Publishers and author can accept no responsibility for
any consequences arising from the information, advice or
instructions given in this publication.

Readers are permitted to reproduce any of the artwork in
this book for their personal use, or for the purpose of selling
for charity, free of charge and without the prior permission
of the Publishers. Any use of the artwork for commercial
purposes is not permitted without the prior permission of
the Publishers.

Suppliers
If you have difficulty in obtaining any of the materials and
equipment mentioned in this book, then please visit the
Search Press website for details of suppliers:
www.searchpress.com

You are invited to visit the author's website at:
www.fionapeart.com

Extra copies of the outlines are also available to download
free from the Bookmarked Hub: www.bookmarkedhub.com.
Search for this book by title or ISBN: the files can be found
under 'Book Extras'. Membership of the Bookmarked online
community is free.

Busy Bee on Yupo paper
7 x 14cm (2¾ x 5½in)

*Painted using wild rose, shadow, country olive, sunlit gold and
yellow gold, with a touch of bluebell for the wings.*

Acknowledgements

I would like to thank commissioning editor Katie French for
her patience in asking me whether I would write another
book for Search Press; the time never felt right until she
asked me to write this one.

My sincere thanks also goes to my editor Edward Ralph
for his hard work behind the scenes, and to Mark Davison
for his wonderful photographic skills, evident throughout
this book.

My thanks also to all of the staff at Search Press including
all the warehouse staff and those working so diligently
behind the scenes, creating and distributing such
wonderful practical art and craft books. My special thanks
go to Freddie Josland who agreed at the very start to
support and encourage me throughout the writing process.
Little did he realise how it would dominate my time for
almost two years!

Many of the paintings in this book were inspired by my
visits to Batsford Arboretum. The beautiful mature trees
and gardens offer a calm place of contemplation and a
wealth of inspiration, so my thanks go to them also.

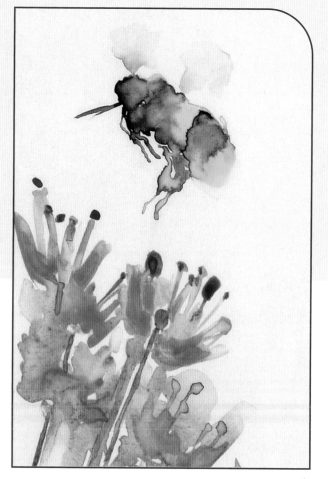

Contents

Introduction 6

Materials 8

Getting started 14
Greetings card – step-by-step 24
Daffodils in Spotty Mug – step-by-step 34

Colour and tone 38
Sweet Mock Orange – step-by-step 54

More ideas and techniques 62
Majestic Magnolia – step-by-step 72

Finding your own way 82
Camellias – step-by-step 96

Creating movement 106
Blue Hydrangea – step-by-step 118

Index 128

Summer Poppies on Yupo paper
15 x 26cm (5¼ x 10¼in)

I began with the centre of the open poppy, then moved straight on to the taller poppy. I painted the centre, then the petals and the stem that leads to the petals of the first flower. Working around the dry centre of the first poppy, I finally added the stem.

Introduction

One of the beauties of watercolour is that it is so adaptable to your circumstances and the time you have available. There's no need to set aside lots of time to paint. While a more complex composition might take an entire day, a simple picture, such as the busy bee on page 4, may take only a few minutes. To encourage you to go ahead and pick up your paintbrush, my focus is on how you can achieve successful paintings quickly and using the minimum of equipment.

If you have never painted before and it is something you would love to have a go at, then this book is for you, the absolute beginner. We begin with the simplest of techniques, enabling you to get used to how the paint feels and moves while at the same time making unique greetings cards and bookmarks, so you have something to show off. Building on these skills throughout the book, we will then learn how to develop your ideas and take your painting further.

Included in this book are outlines which will fast forward you straight to the painting stage. These can be traced and transferred or gently removed and used multiple times. I hope you will create your own line drawings to add to these outlines, and build up a wealth of reference for the future. The outlines can be used in their entirety or sections can be overlaid and repositioned resulting in new compositions of your own – I'll show you how within.

Once you grow confident using your paints, there are a variety of techniques later in this book that will help you to develop your skills. Through allowing the watercolour to move more freely, you'll learn how to create textures suggesting depth and interest that you will be able to build upon as you progress.

I have included lots of examples and tips which I hope will inspire you not only to paint, but also to look at things a little differently, so that you will always have inspiration when you have time to paint.

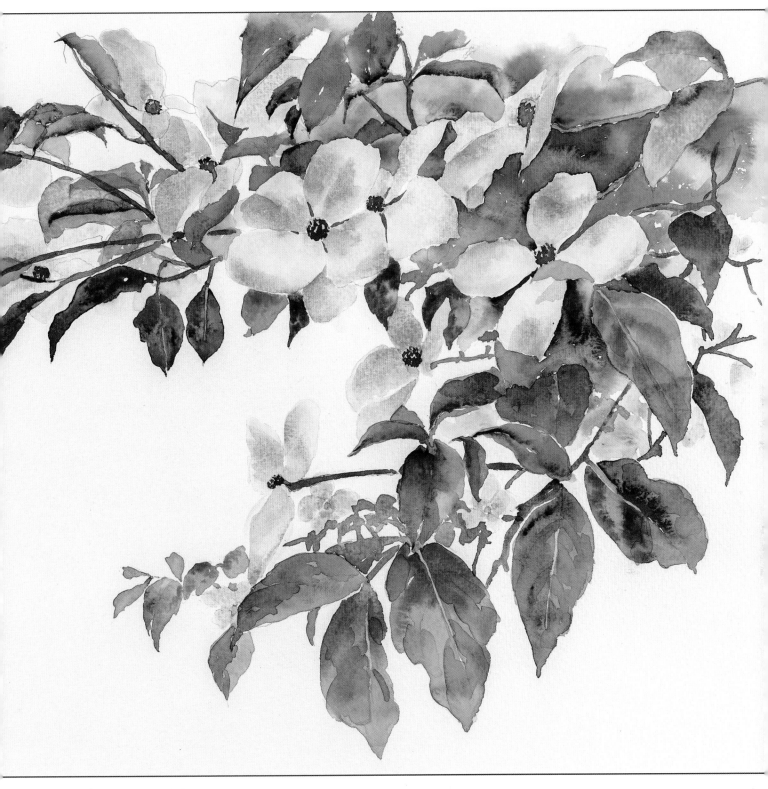

Cornus 'Norman Hadden'

56 x 35cm (22 x 13½in)

These flowers are very similar to a clematis, the centres of which later transform into seed pods. For the flowers I used the colour bluebell and turquoise. For the rest of the painting, I used sunlit green, country olive, midnight green and a touch of autumn gold to darken and create the branches. This painting uses the same techniques as that used in the Camellias project on page 96.

Materials

Deciding what materials to use is very personal, but it is surprising how little we need to begin to paint. If you already own art materials, then use what you currently have and add to them as you go along. If you own no materials at all, this part of the book will give you a good idea of what to get in order to make a start.

Brushes

Watercolour brushes can be made from natural hair (such a squirrel or sable), synthetic hair or a mixture of the two. Natural hair brushes tend to be softer, hold more liquid and are more responsive – that is, you can control how much paint is released by altering the pressure you apply. Synthetic brushes cost less, have more 'spring' and release the liquid in a less controlled way. My preference is to use natural-haired brushes.

Classic round This will be the brush used most for the projects and exercises in this book, and although you can begin with one, ideally you need two of these. A size 10 brush holds ample paint and comes to a fine point. This makes it versatile, ideal for painting a variety of shapes from thin to wide, depending on how much of the brush is pressed against the paper, and the pressure you use.

Pointer This brush has a large belly (so holds plenty of paint), but tapers to a fine point, allowing for fine detail. It has the advantage of having a synthetic core and point surrounded by natural hair, so it has a good reservoir which feeds the synthetic point of the brush, enabling us to use the brush for lovely long strokes or multiple strokes without having to reload the brush from the palette too frequently. It is good for painting details such as tiny little stamens, for example. You can use a size 6 round instead, if you prefer.

Golden Leaf brush This is a 25mm (1in) flat brush with natural hair. You will not need this brush to begin with, but it is great for speeding things up, and when trying out the more advanced techniques later in the book. It is perfect for wetting the paper, applying coloured washes, and suggesting textures by stippling and lifting out paint.

Classic round brushes (size 10)

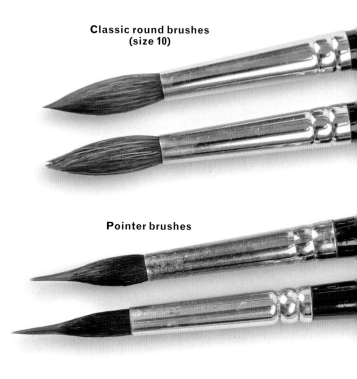

Pointer brushes

Golden Leaf brush

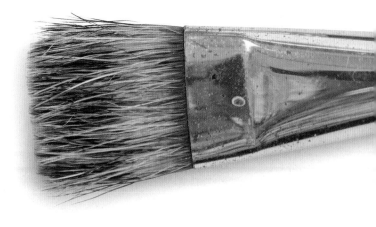

Paints

Watercolour paints are pigments suspended in liquid. Once placed on the paper, the water dries by evaporation, leaving the pigment to settle on or be absorbed into the paper. Some pigments can be rehydrated and removed while others leave a residual stain if an attempt is made to remove them.

Watercolours are easily transportable, dry quickly, are clean to use and require little or no surface preparation. They are available in either pans or tubes. Pans are solid blocks of pigment which come in either full- or half-size blocks. The advantage of pans is that you only need one compact paint box. All your colours are always at your disposal, there is no waste, and you can close the lid and walk away at the end of a painting session. Tubes are very convenient for mixing larger amounts of colour and they do not wear out brushes as much as pans.

I recommend the paints shown here, from the Terry Harrison range, as they have the advantage of avoiding the need to mix particular hues, but you can substitute your own paints if you prefer. Look for ones with similar qualities.

You need access to all of your colours while you paint. Watercolours can look deceptively similar in the pan or palette, so until you become familiar with your colours, lay them out in the same order in your palette (whether pans or tubes) to make it easy to see which colours to use when selecting your colours or mixing them.

Yellow gold
A brilliant primary yellow that can be diluted for a soft lemony glow. Ideal as a dilute glaze on top of dried colours to brighten them.

Sunlit gold
A beautiful vibrant gold. This is difficult to mix while retaining its brightness. When diluted, it is useful to create an ethereal 'glow'.

Sunlit green
A fresh crisp spring green. It is difficult to mix from other colours while retaining a transparent bright result.

Country olive
A natural summer green, which is neither too yellow nor too blue. The most versatile green in my palette, and an ideal base for any floral painting.

Midnight green
A deep dark velvety green, on the blue side.

Turquoise
Very bright turquoise, this is almost impossible to mix from other colours. It is a fabulous colour which will liven up any painting.

Ultramarine
A brilliant primary blue. Used dilute, this allows you to produce soft blue grey-greens.

Bluebell
The elusive colour of bluebells. This vibrant, fresh colour will rush across a wet surface, pushing other colours away – really useful for ethereal effects.

Shadow
A wonderful deep purple used to darken greens. When mixed with pink or blues, or diluted on its own, it creates fabulous mauves.

Wild rose
A bright, luminous colour, essential for floral paintings. It retains its lovely brightness when mixed with blues and mauves and results in transparent darks when mixed with green.

Cadmium red
A brilliant and versatile primary red.

Autumn gold
A rich orange colour which is not too yellow and not too red. A wonderful transparent warm colour.

Watercolour paper

You can paint on any paper, but if your paper is too thin, the paper will cockle and the paint will pool, so your paper needs to be a certain thickness to avoid this. Paper thickness is denoted by weight: 300gsm (140lb) is ideal.

Watercolour paper is treated, or 'sized', so that the paint doesn't soak straight into it. Avoid sketch paper or cartridge paper, which are unsized, and look for paper that is suitable for watercolour.

Paper can also be synthetic, or natural. To begin painting, I would recommend a translucent synthetic paper, as any mistakes can be wiped away easily. If you prefer a natural surface, use a wood pulp paper such as Bockingford. Avoid cotton rag paper when starting out, as this can be very absorbent, and is also more expensive.

Surface texture

Watercolour paper is available with different surface textures, from the smoothest – called HP (short for hot-pressed) – to the roughest, called Rough. In between these extreme is Not surface paper, which is short for 'not hot-pressed'. I recommend you start with using a smooth HP paper.

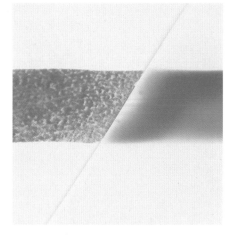

A single paint stroke made over both watercolour paper (left) and synthetic paper (right). This shows you the difference in how the wet paint behaves on each.

HP watercolour paper

Not surface watercolour paper

Rough watercolour paper

Synthetic paper

Traditional watercolour paper is made from wood pulp. Synthetic papers are made from various materials, like cellulose or plastic. It is an intriguing alternative to traditional watercolour papers, particularly due to its strength and because it's easy to adjust or remove paint (see page 22) from the surface.

I recommend Yupo, which is a non-porous, acid-free synthetic paper which is machine-made from pure polypropylene, so it is fully recyclable. Unlike wood-based paper, Yupo is waterproof, strong and stain-resistant. The super smooth surface allows you to create lovely textures and, because it can be wiped clean (even when dry), you have the option to return to specific areas and redo them or indeed wipe everything away and start again. Finally, it is also translucent, so you can place the outlines behind a sheet and start painting without any drawing at all – magic!

Yupo synthetic paper

Painting on different surfaces

Watercolour paint behaves differently on different papers. Compare the examples below, for example. I used the same colours and techniques on all three types of surface – just look at how different the results are.

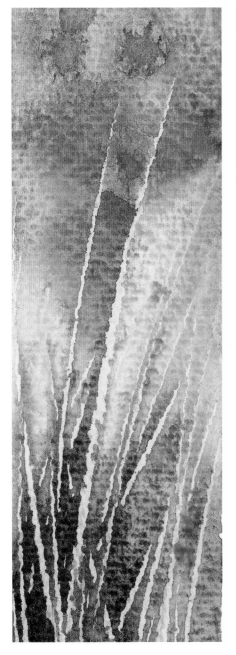

Not surface 300gsm (140lb) wood pulp paper
The paint settles into this paper and is slowly absorbed, resulting in a gentle, even spread of pigment that emphasizes its full colour.

Smooth surface glossy 240gsm (120lb) cellulose synthetic paper
The paint sits on the surface of this paper and is not absorbed. It dries quickly, leaving clean sharp edges.

Smooth surface 240gsm (120lb) semi-opaque Yupo synthetic paper
The paint sits on the polypropylene surface of the paper, and is not absorbed. It takes the longest to dry of the three surfaces, resulting in softer edges and a looser, more suggestive result.

Other equipment

Board (A) A lightweight board is important. You can secure your painting to it, and it also enables you to tilt the board or work flat as you need to.

Palette (B) A large flat area for mixing colours and seeing how the colours change as they mix with others is vital. Most palettes include a number of flat mixing places, called 'wells', along with spaces for you to squeeze small amounts of each pure paint, to help keep them separate and clean. To begin with, you could use a white plate and arrange the colours you intend to use around the edge, using the centre for mixing. I recommend a palette with a lid, to help prevent your paints from drying up.

Water pot (C) This should be big enough for you to be able to swill your brushes around, rinsing them thoroughly. It is a good idea to use two, one for the first rinse, and the other to ensure the brush is totally clean.

Masking tape (D) Low-tack tape is best as this ensures the paper surface does not tear as you remove it.

Kitchen paper (E) Used for absorbing excess water from your brush or lifting paint, it is also useful in case of spills!

2B and 5B pencils (F) Softer pencils like these are easy to erase but wonderfully dark if you wish the line to remain as an intrinsic part of your painting.

Propelling pencil (G) The advantage of a propelling pencil rather than a standard pencil is that the line created is uniformly fine and of course you always have a perfect point. I choose 2B leads.

Eraser (H) A kneadable putty eraser will lift the graphite gently from the paper without scuffing the paper surface. It can also be rolled over a surface to lighten an entire drawing prior to painting (see page 54).

Sticks (I) Hardwood sticks that can be found on a walk in the park or the woods can be snapped to size and sharpened with a pen knife to create an ideal tool for applying masking fluid or indeed paint. I have a series of these, ranging from very narrow to quite chunky and wide.

Masking fluid and brush (J) Masking fluid is liquid latex. When painted onto dry paper and allowed to dry, it acts as a barrier to the paint. When the masking fluid is later removed, the clean white paper is revealed. A nylon brush is used to apply masking fluid. It comes to a fine point and can easily be rinsed off with water after use. A shaper tool, which looks like a paintbrush, but has a flexible silicone tip rather than hairs, is useful if you want to avoid using a brush to apply masking fluid – the silicon tip just wipes clean.

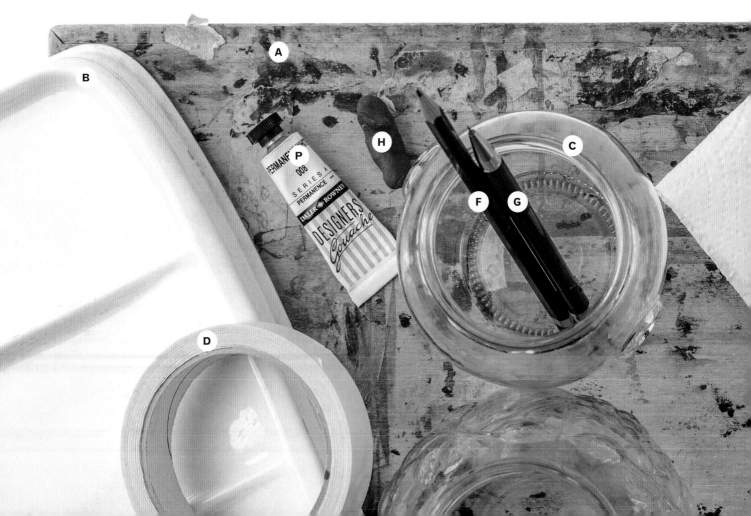

Soap (K) This is used to coat your brush before you dip it in the masking fluid. The soap acts as a barrier and makes cleaning the brush much easier.

Ruling pen (L) Another tool for applying masking fluid, a ruling pen is is also wonderful for painting grasses or any thin lines in watercolour. It's particularly well-suited for applying masking fluid as it rinses off very easily. The width of the line is determined by the space between the pincers, which can be adjusted by turning the wheel on the pen. The wider the pincers, the broader the line.

Palette knife (M) Used later on to help move paint in expressive ways.

Cotton buds (q-tips) (N) Perfect for dipping into wet paint, then gently placing onto paper to suggest berries.

Table salt (O) Ideal to create textures in watercolour by absorbing the wet pigment from the paper.

White gouache (P) A chalky opaque paint, gouache is ideal to use to add small subtle details to finished paintings. Mixed with a little watercolour, white gouache will produce chalky opaque colours that are perfect for painting details, covering sections, or painting a light colour on top of a dark one.

Spritzer (Q) Filled with clean water, this is a good way of keeping the surface wet without touching it with a brush, and also keeping your paints fresh and ready to use.

Masking fluid remover block (R) A soft eraser, this optional item can be used to remove masking fluid if you don't want to use your finger.

Ruler (S) This is used in the first project to help make a clean, straight fold for your greetings card.

Pigment ink (T) Not to be confused with acrylic ink, water-resistant artist's pigment ink can be used with watercolours to produce wonderful gritty textural effects. It is necessary only for more free-flowing techniques towards the end of the book, so it is optional.

Tracing paper (not pictured) Another optional item, this will allow you to transfer the outlines to opaque paper, as described on page 17.

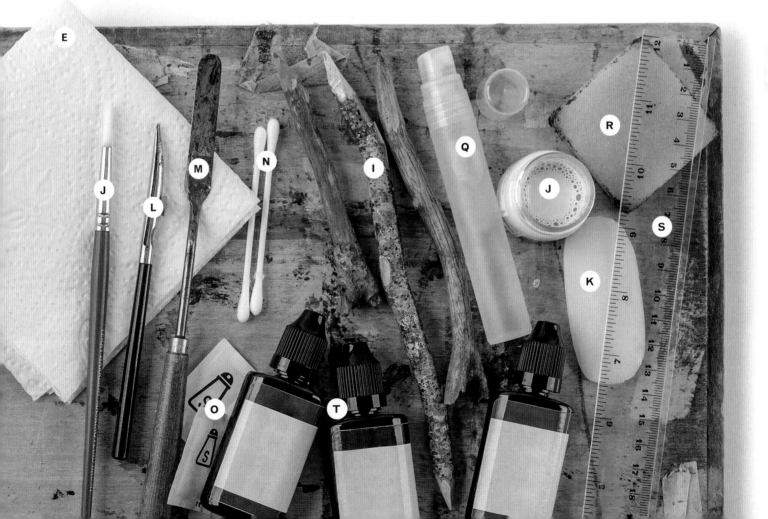

Getting started

With your art materials at the ready, let's cast away any nerves and establish the basics that will lead to a successful painting result.

Firstly, make sure you are sitting or standing comfortably. I prefer to stand, with my table at hip level, but you may prefer yours higher than this. I like to work flat and tilt my paper when I need to.

I am right-handed, so my paints, water pot and brushes are all placed on the right of my painting area; this avoids me having to lean over my work when mixing or transferring paint and water.

How to hold a paintbrush

You might think holding a brush would be the same as holding a pencil or a pen, but that is not necessarily so. To begin, hold the brush at the top of the ferrule, where the metal meets the wood. Not too close to the tip of the brush, nor too far from the handle, is ideal.

If you want to paint more detailed sections, you need to move your fingers closer to the tip of the brush. For a looser approach, move your hand further back down the brush handle.

Preparing your paint

If you are using a box that has watercolour pans, you are ready to begin painting immediately – just dampen your brush and gently agitate the colour in the pan. If you are using tubes of paint, squeeze a little of each paint (about half a teaspoon) into the spaces on your palette. You can top up your colours as you need to.

Before you start, wet the paints you want to use by dipping your brush into your water pot. The water should cover the hair and some of the ferrule but does not touch the wood of the handle. Swill your brush around slowly in the water, then, as you remove your brush, gently touch the tip to the edge of your water pot to remove excess water. Place the wet brush directly onto the full-strength watercolour to wet it.

Watercolour needs to be diluted with water before use. Once wetted as described above, you can prepare your paint as shown below.

15

Tip

I prefer to use a palette with a lid. I can organize it once, then simply top it up with more paint as required.

Keep your paints moist using a spritzer and replacing the palette lid when you take a break.

1 Wet your brush and use it to lift clean water to a well in your palette.

2 Dip the point of your brush into the wetted paint. Gently agitate the brush on the paint surface to load it with a little paint.

3 Introduce the colour to the wet area on your palette and agitate it again to mix the paint with the water. To dilute it to the required strength, repeat the steps to add more paint or water.

Diluting watercolour paint

This exercise will show you how, by adding a little water or a little pigment to your palette, you can change the strength and consistency of the prepared colour.

Before applying paint to paper, roll your brush into your prepared colour to ensure that the whole brush is loaded with the colour – avoid having colour only in the tip of the brush.

Paint a small swatch of colour onto your watercolour paper using the whole brush and allow this to dry.

Dip your brush into the water, touch the side of the water pot, then straight back onto your mixed colour and swirl your brush into the colour. This will dilute the colour currently on your palette and reload the brush. Now paint another swatch of colour near to the first. You will notice this is much paler than your first swatch of colour.

Repeat this for an even paler colour or return to the full-strength colour by adding more pigment from the palette space to the mix.

Tip

As you paint, rest your hand on a sheet of folded-up kitchen paper, to avoid transferring oils from your hand to the surface.

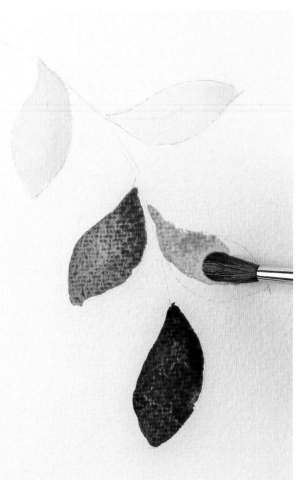

Changing tones

The more water you add, the lighter the colour will be. Your mixed colour will range from its full colour (bottom) to very pale (top).

Using the outlines

The outlines provided here mean that you can get started without having to practise your drawing skills – and if something goes wrong, you can reuse them as many times as you wish.

They are printed on lightweight paper so that you can easily remove them from the book. If you prefer to keep the book intact, you can instead use tracing paper to copy the outline and transfer it to the painting surface you want to use, as described on page 17.

The outlines are numbered for easy reference, and if you want to try the larger, more ambitious variations on the main projects, the additional outlines are available for free download from the Bookmarked Hub: www.bookmarkedhub.com. Search for this book by title or ISBN: the files can be found under 'Book Extras'. Membership of the Bookmarked online community is free.

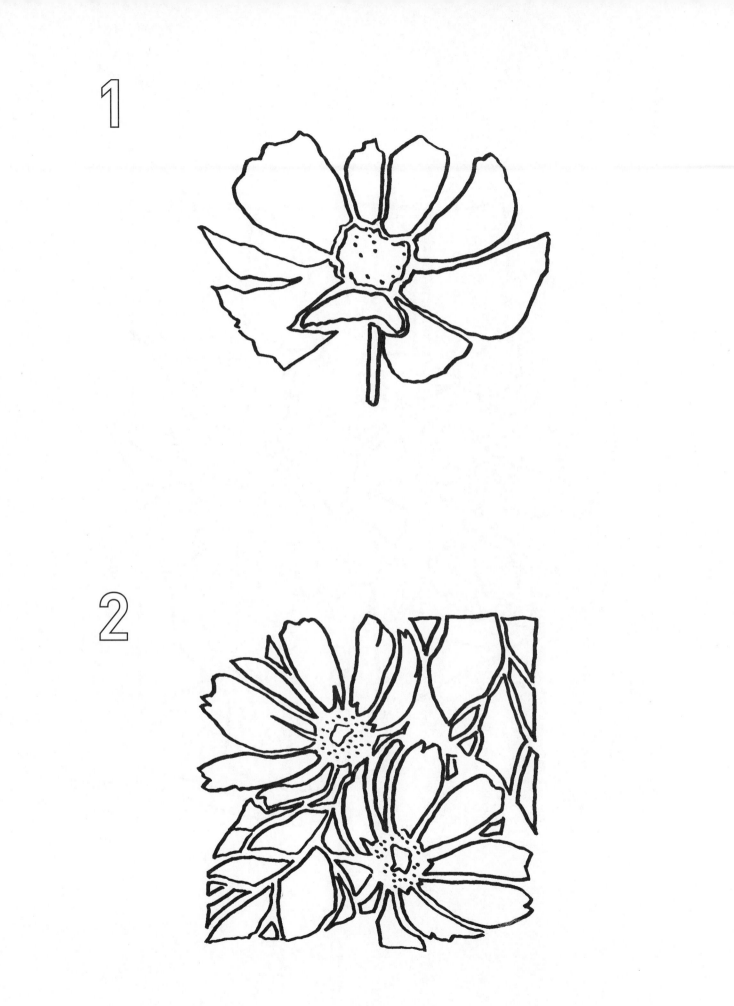

3

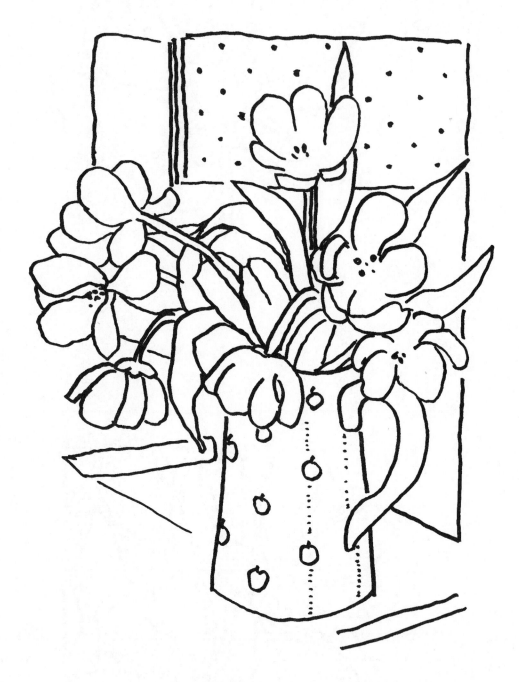

8

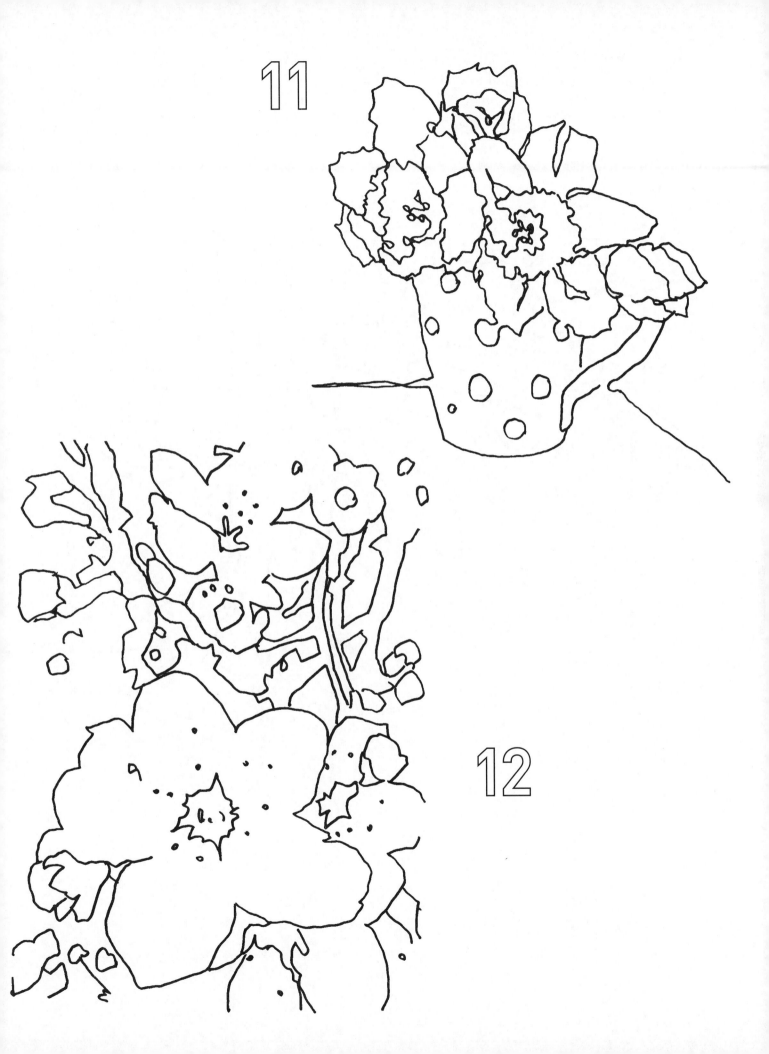

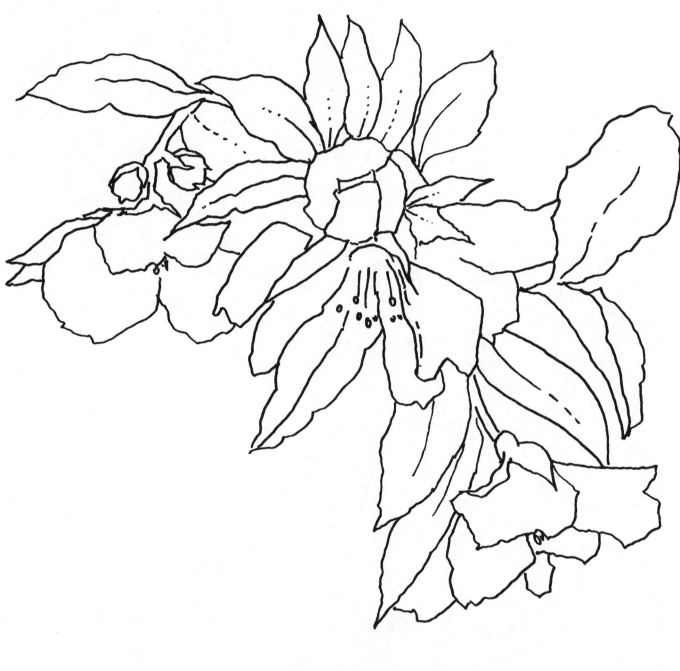

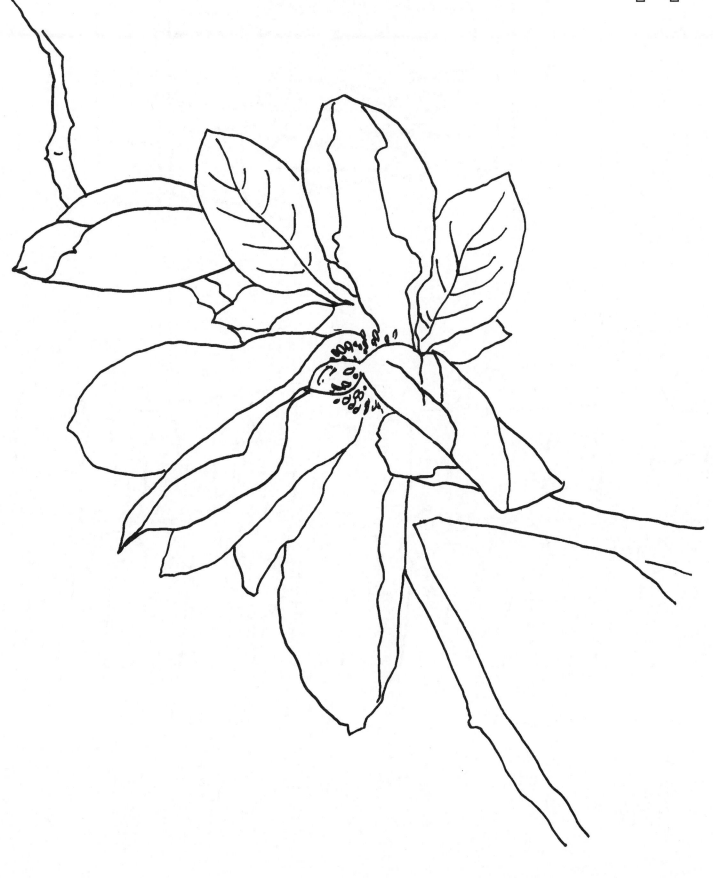

15

16

17

18

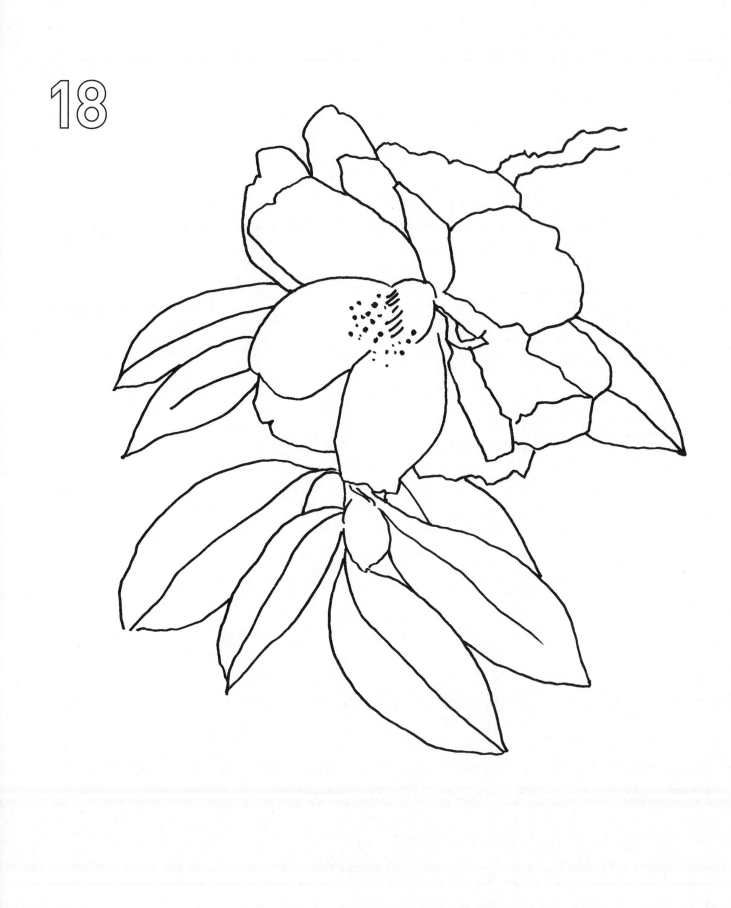

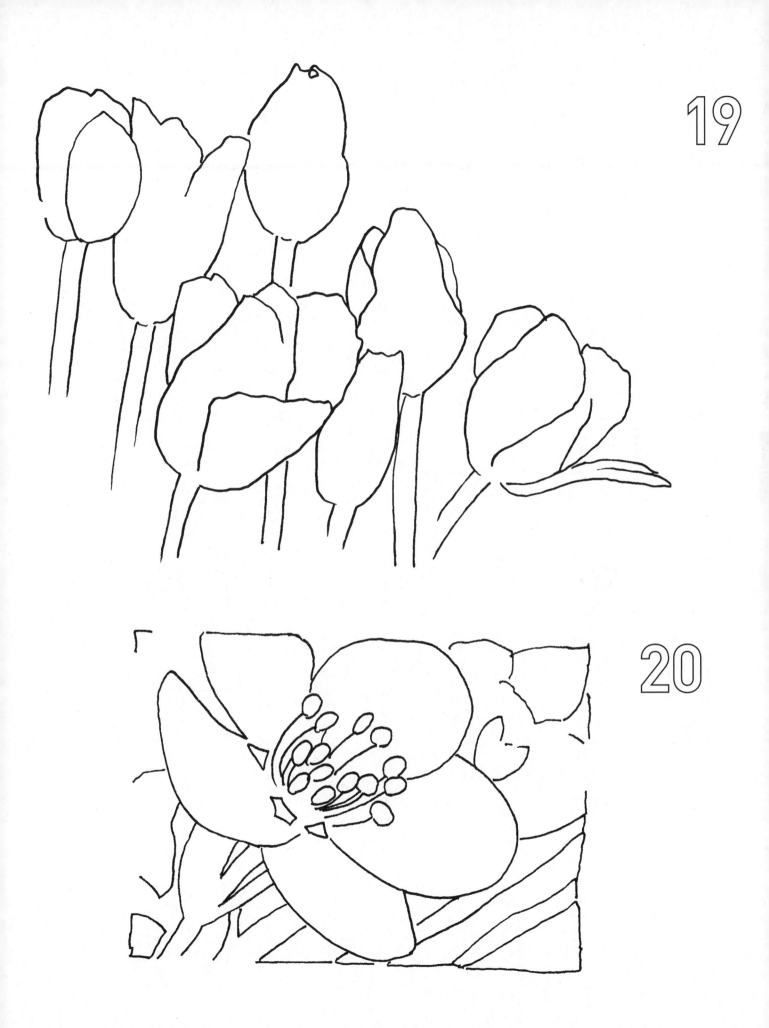

19

20

21

Transferring the outlines to paper

Select the outline you want to use. For heavierweight natural watercolour paper, or opaque synthetic paper, select the outline you need, then lightly trace the image onto your paper using a soft (2B–5B) pencil with a sharp point, or a propelling pencil.

For translucent synthetic paper, or lighterweight natural watercolour paper (up to the weight of 300gsm/140lb), you can use the methods below.

 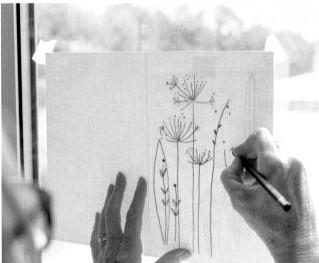

Transferring the outline to synthetic paper

Remove the outline from the book (or trace it) and tape the sheet to your work surface, so that it won't move. Next, place the synthetic paper on top of it so that the image is visible through the paper as shown above.

Secure the paper in place by taping it at the corners. You're now ready to go – just leave the outline in place while you paint; no drawing is required.

Once you have finished your painting, and have allowed it to dry, use tape to mount the synthetic paper on a sheet of plain white cartridge paper to display it.

Transferring the outline to lightweight natural paper

Remove the outline from the book (or trace it), then place it against a window or lightbox and tape it on the top corners. Next, position your watercolour paper on top so that the image is visible through the watercolour paper. Secure the paper at the top two corners.

Using a soft pencil (such as a 2B or a 5B) with a sharp point, or a propelling pencil, lightly draw the lines onto your watercolour paper.

Painting a single flower with a round brush

This example of a single flower uses just three colours. It involves creating shapes and is the simplest way to start. It's a good opportunity to get used to how much paint is needed to load your brush, and will teach you to paint 'wet on dry'.

The shapes you paint should glisten with wet colour. If you feel the brush is too dry, re-load it. If you run out of paint, mix a little more. If one section of wet paint touches another, the colours will flow into each other. This exercise is a chance for you to practise keeping those shapes apart.

While you can use any surface, I recommend you try Yupo synthetic paper for this exercise, because the paint will take a little longer to dry on this than on natural paper – and produce beautiful effects while it does so. Secondly, if you make a mistake, you can simply use a damp piece of kitchen paper to wipe any paint off the surface. It's perfect for practising your first steps.

Outline 1

You will need:

Paper: 20 x 20cm (8 x 8in) sheet of Yupo synthetic paper

Brushes: size 10 round

Paints: cadmium red, country olive, shadow

Soft pencil, such as a 5B (if you are using watercolour paper)

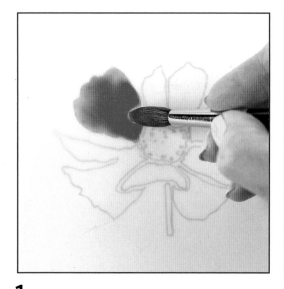

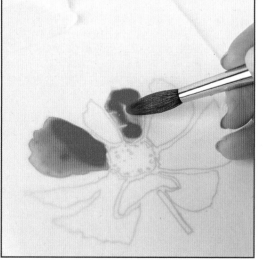

1 With the outline in place behind the synthetic paper (see page 17), load the size 10 brush with cadmium red and move the brush around the first petal shape, making sure that it is glistening with wet colour.

2 If you feel the shape needs more colour, tap the brush onto the paper to release more colour. Once you are happy, move on to the next shape. To help reduce the risk of two areas touching (which will make them flow into one another), pick a non-adjacent petal.

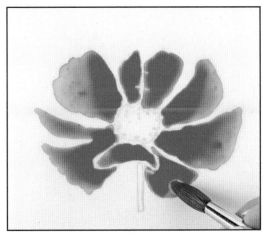

3 Continue working round the shape, working alternate petals in turn. By the time you come back to the start, the first will have started to dry, so you can move on to fill in the petals in the gaps, until all the petals are done.

4 Rinse your brush thoroughly, then prepare country olive in a new well on your palette. Load your brush and use the tip to paint the stem.

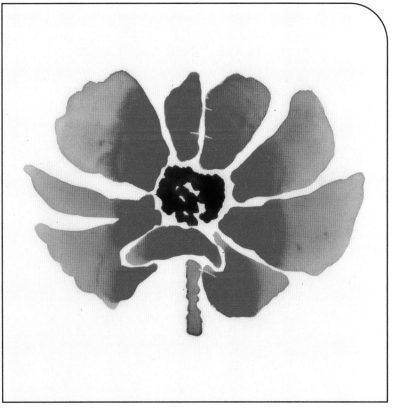

5 Allow to dry. Finally, using the colour shadow, paint the centre, leaving tiny sections of the paper to suggest seeds. Allow all the paint to dry thoroughly – it may take more than an hour on Yupo, so leave it flat, somewhere undisturbed.

The finished picture
This has been taken off the outline, then secured to a piece of plain white cartridge paper to ensure it looks fresh and bright when displayed.

Tip
It's easy to check whether paint has dried on Yupo – once the shine has gone, the paint is dry. To test whether paint has properly dried on natural woodpulp paper, you can gently touch the surface with the back of your hand. If it feels cool, it's not quite ready.

◼ Allowing colours to meet and merge

Painting two different colours within the same shape and allowing them to merge while they are still wet creates some lovely effects. This is a way of painting called 'wet-into-wet', where we allow different areas of wet colour to touch on the surface. It is a wonderful way to learn what happens when two colours gently mix on the paper, as opposed to mixing them on the palette.

This pink open flower is a lovely little project for you to try. Don't worry if some sections touch each other or run into each other; have fun, experiment and see what happens. Once you've had a go at the colours I suggest here, why not try again with some other paint to see what results you get with different mixes?

You will need:

Paper: 15 x 15cm (6 x 6in) sheet of Yupo synthetic paper

Brushes: size 10 round, Pointer

Paints: wild rose, cadmium red, country olive, turquoise, shadow

Soft pencil, such as a 5B

1 Secure the outline in place behind your paper, as described on page 17. Using a size 10 round brush, and the colour wild rose, mix a dilute pink on your palette by adding water to your colour. Beginning from the outer edge of the petal, paint two-thirds of the first petal.

2 While this is still wet, switch to the Pointer brush. Use cadmium red to paint a strong colour from the centre out towards the previous wet section of each petal, until they just touch.

3 Continue around the flower, and paint all the petals in the same way.

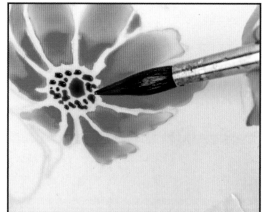

4 Using the Pointer and shadow, paint the tiny dots in the flower centre, then the larger centre.

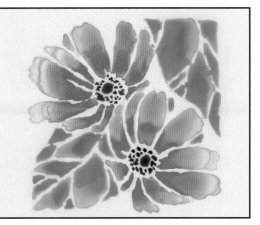

5 Using two colours, country olive and turquoise, start painting the leaves in the same way as the petals, adding the first colour in one direction, then bringing the second to meet the first from the other direction.

6 Paint the remaining leaves. Avoid the temptation to stir up or mix the colours together on the paper. Allowing the pigments to mix and merge by themselves gives a more luminous result. Leave this all to dry thoroughly, then gently remove the outline.

The finished painting

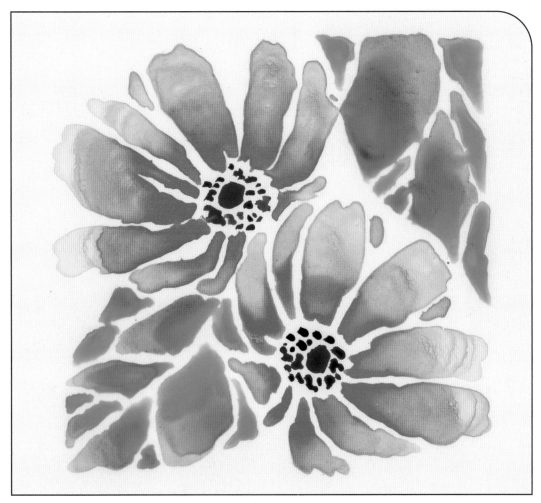

Lifting out and adjusting paint

Synthetic paper is an ideal surface for removing any sections of unwanted paint, whether it is still wet or has dried. As the paint is not absorbed into the paper, it remains on the surface, allowing us to remove it whenever we wish. Practising these techniques on synthetic paper will give you the confidence to use them on natural watercolour paper.

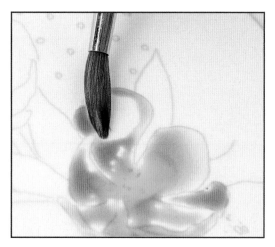

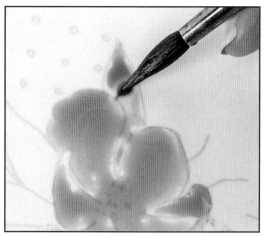

Thirsty brush

While the paint is wet on the surface, you can lift it out with a 'thirsty brush'. It shouldn't be bone dry; load the brush, then tap off any excess water on the side of the water pot. To use it, draw the thirsty brush through the wet paint, smoothly and gently. The wet paint will wick up the hairs of the brush as you work. We look at this in more detail on page 66.

Pulling wet paint

If two areas of wet paint touch, they can start to bleed into one another. Sometimes you want this effect, but if you want to avoid it, you can pull one section back. Don't lift the brush from the paper. Press down slightly more as you draw the brush away. Like the wake of a boat, it will pull the paint you're applying away.

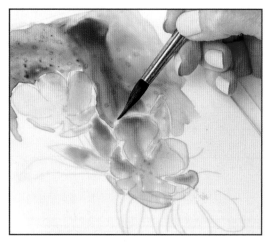

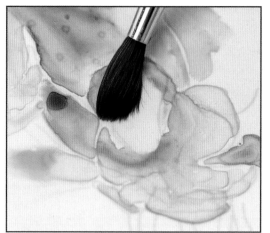

Shepherding loose paint

Help! What if the paint runs too much? Use a thirsty brush to draw a line to create a barrier. The paint will now not run together, as wet paint will not flow onto dry areas.

Lifting out dry paint

Even when the paint has dried, you can lift out effectively from Yupo. Simply use a damp brush to gently touch the surface. This will reactivate the paint and it will be drawn up the brush, leaving a lighter or clean space. Lifting out is as simple as using a clean thirsty brush to wipe away the paint from the surface.

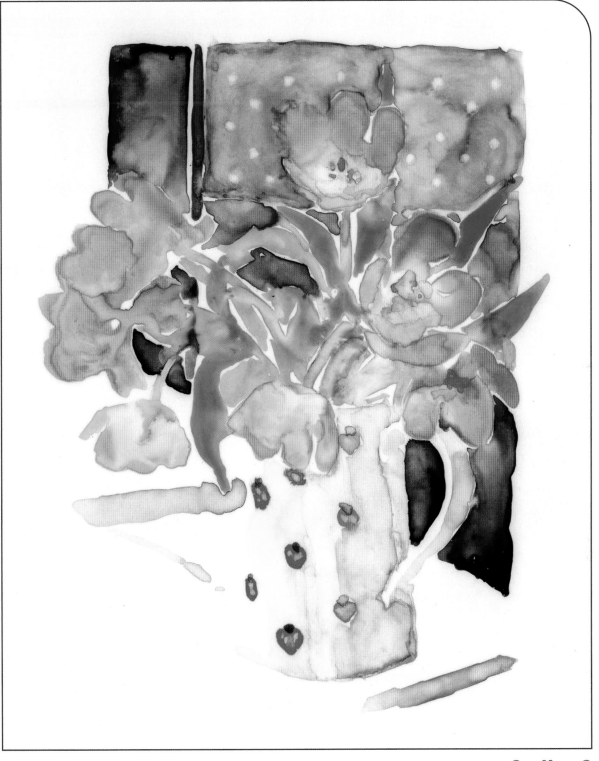

Tulips in a Strawberry Jug

13 x 17cm (5 x 6½in)

Use the techniques on pages 18–21 to have a go at painting these wonderful blown tulips. Don't worry if the watercolour escapes into an adjoining section – if it's not what you want, you can always move it or lift it if you are using synthetic paper. Have a go at lifting some little dots on the background; and remember that your painting is only finished when you're happy with it.

Outline 3

Greetings card

The natural world is full of inspiration which we can simplify and adapt, allowing us to incorporate those shapes we find pleasing. **By** using simple design shapes and arranging them differently each time we begin, we are able to create individual artworks each time. **Not** only will the composition be different, but each of our projects will be unique, depending on the colours we use and the sections we paint or leave.

All the design elements needed to complete a series of cards are included in the outlines section. It will be easier if you trace and cut around the individual designs so that they can be moved, overlapped and reversed around your paper. **Once** cut, store them in an envelope so that you can reuse them time and time again.

Outlines 4-9

You will need:

Paper: 30 x 21cm (11¾ x 8¼in) sheet of 300gsm (140lb) smooth watercolour paper

Brushes: size 10 round

Paints: wild rose, sunlit gold, ultramarine

Soft pencil, such as a 5B; masking tape; scissors; tracing paper (optional); ruler

1 Cut a sheet of watercolour paper out of your pad and fold it in half. Make sure the top remains facing towards you. The reason for this is that watercolour paper has a top surface and a reverse. Although you can paint on either, the top surface is better to paint upon. Fold the corners together, then use a ruler to make a clean, sharp crease.

2 Open the card back out and place it face-down on your painting surface. Make sure you're painting on the right-hand side of the crease, as this will be the front of the card.

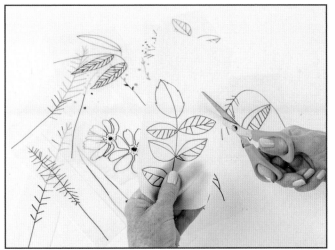

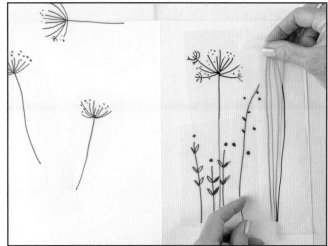

3 Cut out the individual design elements from outlines 4–9. If you don't want to cut up the book, or you want to use the same element repeatedly, you can instead trace the designs and use the tracings, as I am doing here.

4 Select the elements you think you might like to use and begin to place them on the front of the greetings card to build up a design. Try different angles, and overlaying the different elements.

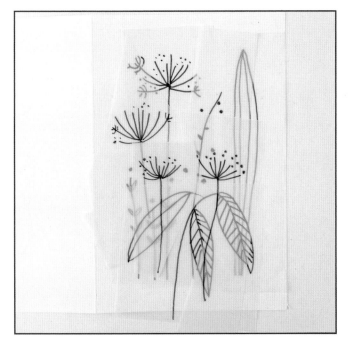

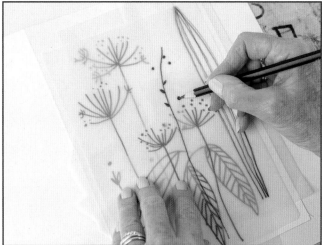

5 Move the elements around, adding more or taking away, until you have a design that you like. Note that you can flip the traced elements over if you want to, to get a mirror image. You can also just use part of an element – you're free to compose as you wish.

6 Once you're happy, use masking tape to secure the pieces in place and transfer the design as described on page 17. Alternatively, you can lay a sheet of tracing paper over the top and use a 5B pencil to copy the design. Remember, you don't need to copy everything – feel free to leave parts out if it helps your design.

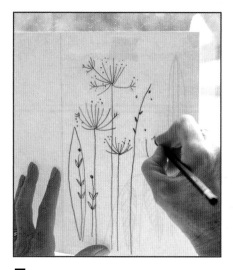

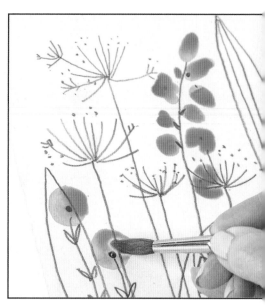

7 Tape your tracing to the window, then tape your card to the window over the top. Use the 5B pencil to copy the lines across. You're all ready to paint!

8 Using the size 10 brush, prepare wild rose on your palette. Add sunlit gold to the paint in the palette well to create a warm mix.

Tip
You can choose any pair of bold colours for your greetings card.

9 Pick up the mix on the brush, and begin to pick out some simple shapes, using the dots on the design as flower centres. Add a few where there are no dots, too – this ensures your flower heads are not all pointing in the same direction.

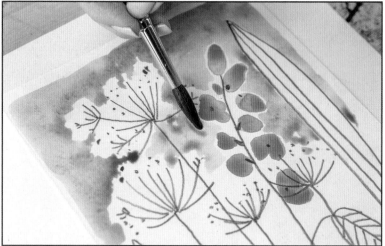

10 With these flowers established, we can now add the background. Prepare a large well of ultramarine. You need plenty; you don't want to run out halfway through.

11 Leaving a small border near the edge, paint in the background (If you're left-handed, it's easier to start on the right, and if you're right-handed, start on the left). Leave space around the cow parsley and other flowers, and only cover the top half of the painting.

Tip
This technique is called 'negative painting' and creates the impression of white florets and sunlight.

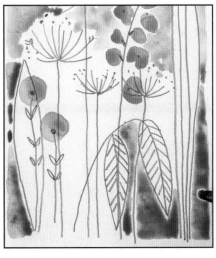

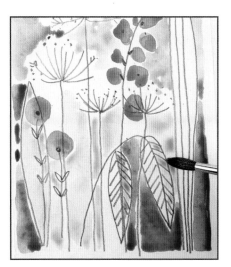

12 In the palette, add some of the wild rose to the ultramarine and gently mix them together to create a purple.

13 Use this strong mix to paint all the dark areas. This will depend upon your design, but will generally be the lower half of the painting, and towards the edges.

14 Add water to the mix in the palette to dilute it, and use the paler mix to add colour between the stems and to suggest form on the leaves.

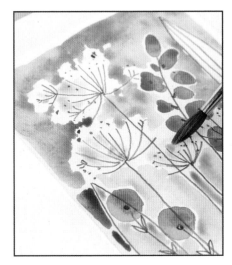

15 Dilute the wild rose and sunlit gold mix with clean water and add some touches to the cow parsley heads. This adds a sense of shape without losing the overall white appearance.

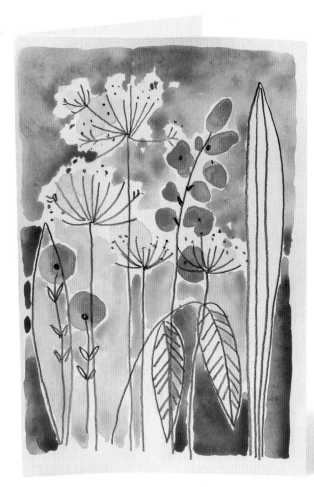

The finished greetings card

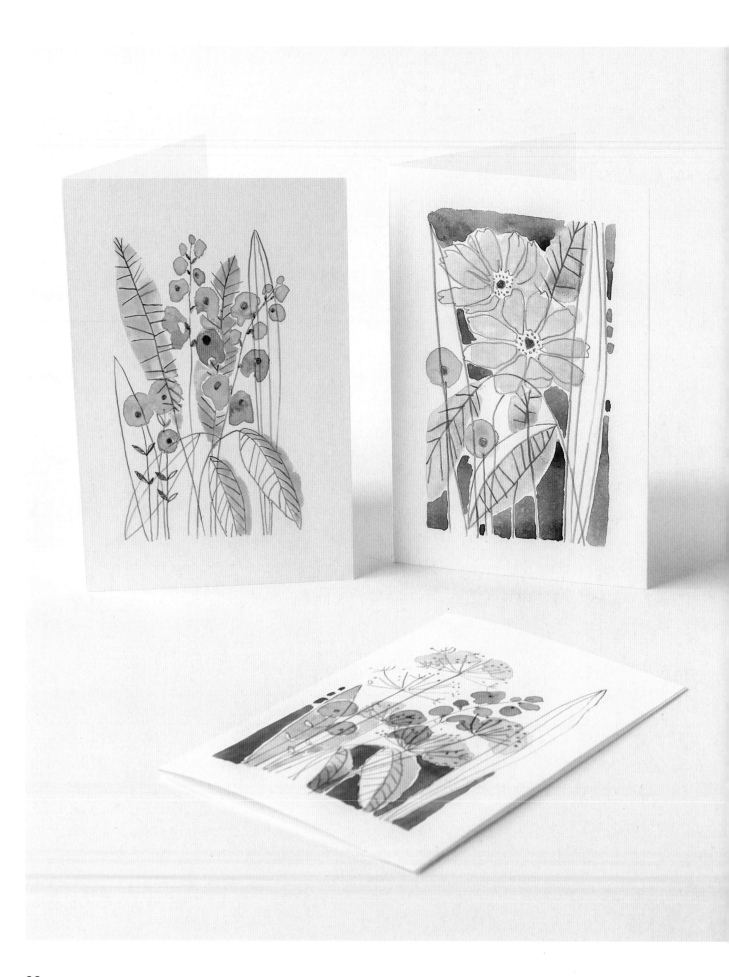

More greetings cards

These were all made in the same way, using different combinations of the designs on outlines 4–9.

When designing your own cards, try selecting a theme such as berries and leaves, small flowers and leaves, or large flowers and leaves. Including too many ideas on one card can be overwhelming. Keeping your ideas simple, and the number of colours you use limited, will result in cards with more impact.

Try making loose colour swatches (see page 39) and placing them in position on top of your drawings to help plan your cards and decide on colour combinations. You will develop your favourite combinations which you can return to time and time again.

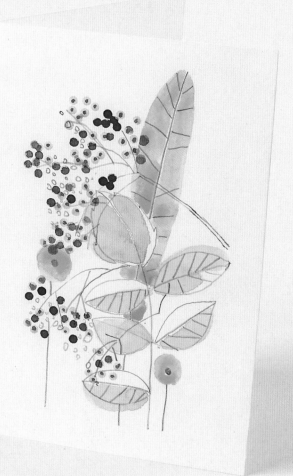

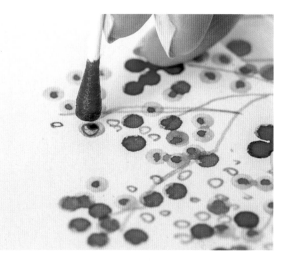

Tip

If your design involves seedheads like this, you might like to try using a cotton bud (Q-tip) to apply the paint. Simply load it from your palette, then tap it on your surface, like a stamp. The wetter the cotton bud, the more solid the berries will appear. If it's a little drier, you'll end up with a central dot, which can be an attractive effect.

Keeping an ideas book or folder

You don't need a formal sketchbook. Sketch paper, with doodles and ideas on it, can be worked on and combined with small experimental pieces of watercolour to help formulate ideas for future projects. These loose sheets of paper can be kept together in a folder.

Shown here is a selection of quick experimental sketches that I make when I have a spare moment, just for fun, or to help develop an idea or explore a combination of colours. Alongside them are my loose colour swatches (see page 39), and some painted bookmarks I've made. I use them for marking interesting magazine articles, or in my cookbooks to flag favourite recipes. When I see a particular flower or leaf peeping out of my recipe book, I know exactly which recipe it is.

Bookmarks

These bookmarks are an ideal project for beginners – quick, simple and useful. Having a practical use for your paintings creates an incentive to develop ideas rather than sitting with a blank sheet of paper in front of you and wondering what to do next. You could make as many as you wish; all will be unique. They also make lovely gifts – and all the while you are experimenting with composition, balance and colour combinations, practising these essential painting skills.

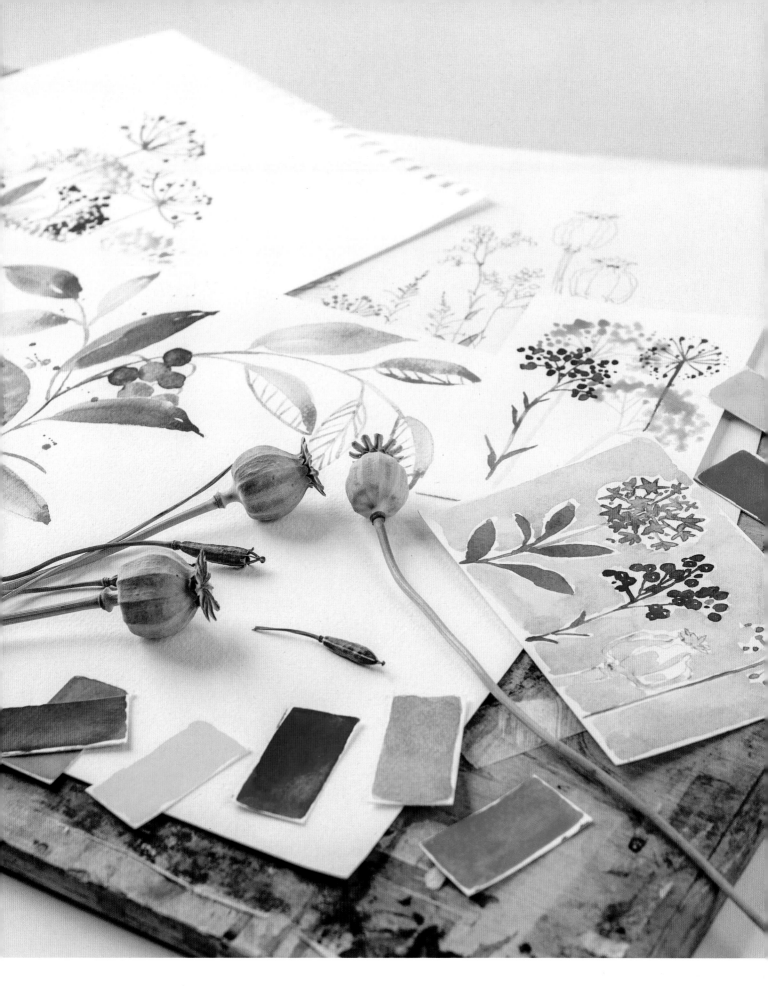

Dropping in colour or water

Flowers can seem quite complicated, especially when they're growing *en masse*, but by focusing on one stem and ignoring everything around it, a single drawing can be created from which a more complex painting can be inspired.

 This exercise is a great way to practise 'dropping in' – that is, allowing the paint to merge and mix with wet paint already on the paper.

 Before you begin, transfer outline 10 onto your watercolour paper. If you feel that the transferred drawing is too dark, roll your putty eraser into a rolling pin shape and gently roll it over the drawing to lighten the marks (see page 54).

Outline 10

You will need:

Paper: 21 x 30cm (8¼ x 11¾in) sheet of smooth 300gsm (140lb) watercolour paper

Brushes: two Pointers

Paints: sunlit green, sunlit gold, turquoise and wild rose

Soft pencil, such as a 5B

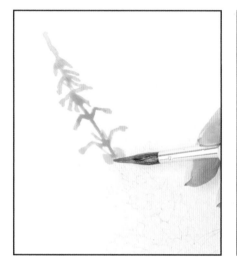

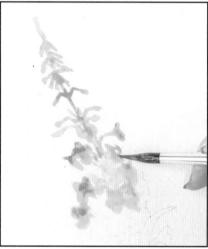

1 Beginning at the top of the stem, using sunlit green, paint down the stem, adding water to lighten the colour. While the paint is wet, you can 'drop in' paint, simply by touching the loaded brush to the wet surface. Introduce sunlit gold to the tips of the buds.

2 Using both brushes, work downwards, allowing the flowers and leaves to merge, adding water where you feel you want to dilute the colour and dropping in more pigment where you wish to add depth. Introduce wild rose to the tips of the flowers.

3 Add turquoise to the central stem section. Keep the colours fairly pale, but interesting. Continue building up and dropping in the colours, taking time to see how different paints interact. Once finished, allow the paint to dry completely, then rub out any visible pencil lines.

The finished painting

If you are feeling confident, you might like to add a background. This could be as simple as adding some very pale colours wet into wet (see page 20) to suggest background flowers and leaves.

Alternatively, you might choose to take this project further, adding more flowers, as described to the right.

Taking things further

Try adding a second copy of the outline onto your painting, flipping it over and experimenting with the composition, as described in the exercise on pages 24–27. Feel free to adjust the details, such as lengthening the stem, to better fit the space. Once you have settled on a composition you like, repeat the painting process, this time adding more pigment so that the flowers seem to be in front of the previously painted ones.

Daffodils in Spotty Mug

Outline 11

You will need:

Paper: 16 x 19.5cm (6¼ x 7¾in) Yupo Translucent synthetic paper

Brushes: size 10 round, Pointer

Paints: yellow gold, shadow, sunlit gold, country olive, autumn gold, ultramarine

Daffodils make such a wonderful subject to paint and I particularly love this variety with the bright yellow or orange centres and creamy coloured petals. Once you've had a go at this project, you can recreate a similar subject using fresh flowers rather than using a photograph.

Look closely at the photograph and adapt your own painting as you go along. I use Yupo paper here, but you can equally use watercolour paper. Don't try to paint everything in one go; and don't worry if one section runs into another as we can easily lift any paint. Finally, remember that we're not trying to recreate the photograph, but to produce a beautiful painting.

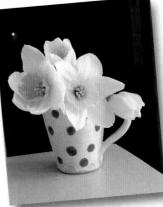

Source photograph

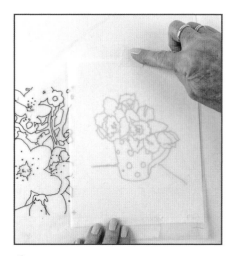

1 Tape the Yupo paper directly on top of outline 12. You can, alternatively, transfer the image to a piece of cartridge paper and work on top of that.

2 Using the size 10 round, prepare yellow gold in your palette. Referring to the photograph, begin to paint in the brightest areas of yellow.

3 Add a tiny amount of shadow to the yellow gold in the palette. This will tone down the yellow, making it less bright.

4 Use the size 10 to apply the mix to darker areas wet-in-wet, then swap to the Pointer brush and drop in touches of this darker mix to areas that you want to strengthen.

5 Add more yellow gold to the toned-down yellow mix to strengthen it, and paint the centre of the small flower at the top. Use pure yellow gold to add the bright centre of the main daffodil, then swap to the Pointer brush and drop in sunlit gold wet in wet. Do the same on the small flower at the top.

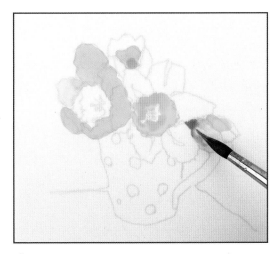

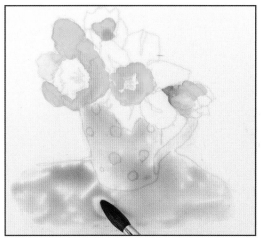

6 Use pure yellow gold to add the bright centre of the main daffodil, then swap to the Pointer brush and drop in sunlit gold wet in wet. Still using the Pointer brush, tap in yellow gold on the left-hand bud, leaving the tips of the petals as clean paper. Paint the sepals with country olive, letting it just kiss the wet yellow.

7 Prepare shadow and add a touch of yellow gold (the opposite of the mix in step 3). Shadow is inherently a very dark-toned paint, so make sure you add plenty of water to create a soft, dilute wash. Use the size 10 round to paint both the mug and the table. Allow the colour to dry completely.

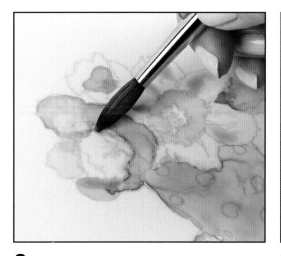

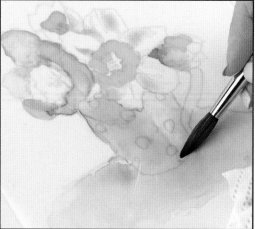

8 Prepare more of the shadow with a touch of yellow gold, and paint the shadows on the pale petals. Note that you're not covering the whole of each petal – just the shadows you can see on the reference photograph.

9 Use a clean damp brush to soften the petals on the left-hand side, if any unwanted hard edges have formed in them, and to reshape and refine the shadow on the mug, lifting it off from the right-hand side.

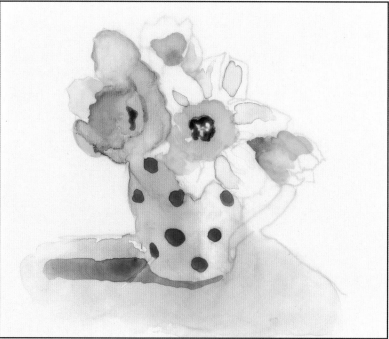

10 Prepare autumn gold and apply it around the edge of the left-hand trumpet, using the point of the size 10 brush. While it remains wet, add yellow gold in the clean area and let the two merge and blend.

11 Still using the size 10 brush, paint the dots and cast shadow of the mug using ultramarine. Swap to the Pointer brush to touch in small overlapping spots of ultramarine in the centre of the flowers, then allow to dry completely.

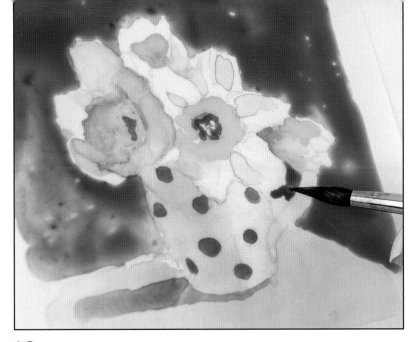

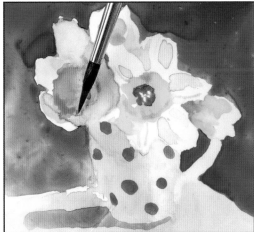

12 Make separate pools of ultramarine and shadow in a well of your palette. Allow them to overlap, but don't mix them together, so that you can quickly get one or other of the pure colours, or a combination. Use the size 10 round brush to paint in the background, swapping to the Pointer brush for the space inside the handle and between the flowers.

13 Make any tweaks or adjustments you feel necessary – here, I have lifted out a little paint from the mug to make the handle stand out – then allow to dry.

Tip

Don't rinse the brush in between loading it from the shared shadow/ultramarine well, to help create a varied, interesting background.

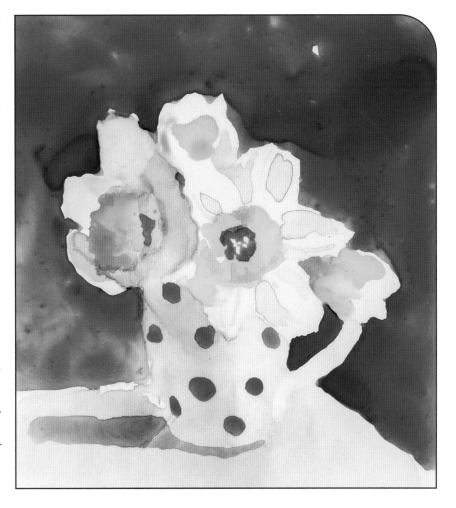

The finished painting

Finishing touches can be really enjoyable to make, but be careful not to over do them! Once you are happy with your changes, remove the Yupo paper from the outline and reattach it to a clean sheet of cartridge paper to finish.

Colour and tone

■ Creating a palette reference

Whether you are using watercolour tubes or pans it is not always apparent what the colour will look like once water is added to it. Creating a reference of colour swatches for your paint palette means that you can dip into the right choice of colour instantly. This becomes even more important the more colours you own.

How to make a palette reference

Making a reference sheet for your palette is useful as it will help you to see what results you will get – results that won't necessarily be obvious from the undiluted paint. The greens and blues of my palette, for example, are very different once applied and dried, but look very similar in the palette.

Prepare each colour to its full strength so that the colour can be clearly seen (add just enough water so that it flows off the brush), then paint small blocks of colour – around 2.5 by 5cm (1 x 2in) in size is ideal – on a clean piece of watercolour paper. Paper that is 300gsm (140lb) in weight and with a Not surface is ideal.

If you are using different colours, compare your results colours to mine. If you don't have the same colour, you may have a similar one, or be able to adjust your colour by mixing it with another.

Tip

Whatever colours you choose, you need them to be varied enough to succeed with colour mixing, but not so many that it becomes complicated using them.

Palette reference

Colours can look very different wet and dry. Here, the autumn gold (far right of image) looks quite orangey-brown and drab in the palette well, but once wetted and applied to the surface, you can see it's a warm, rich and vibrant colour.

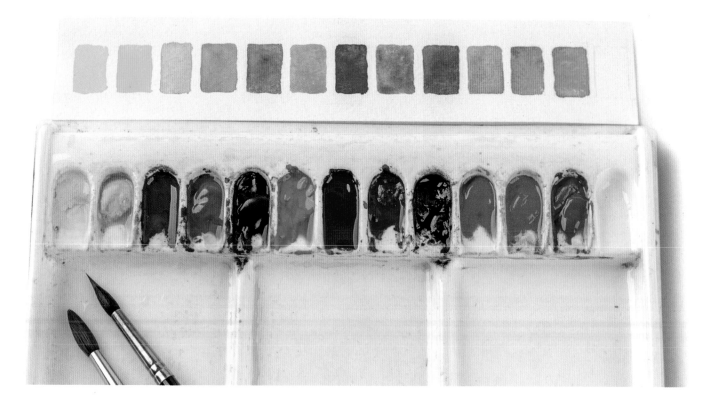

Making loose swatches

Loose swatches of individual colours can be useful to place directly onto a painting before deciding whether the colour is the one you wish to use.

If you have tubes of colour but you don't always squeeze them onto a palette or perhaps use only a limited number of your colours at a time, then having each colour separately can be helpful when choosing which colours to select. These swatches can be made in the same way as the palette reference opposite, simply on small separate pieces of watercolour paper.

Write the names of the colours on the reverse of each card as they can look very different from the illustrations on the tubes once hydrated.

Using the swatches

Individual swatches are great for comparing with flowers from life, photographs, or even from screens, as here. Simply hold up the paint swatches to the colour to find the closest in hue – as you can see here, where I'm trying to find the colour of the central 'trumpet' of the daffodil.

This gives you a good starting point – you can then use that colour as your basis, and make any adjustments through diluting it to change the tone, or mixing with other colours.

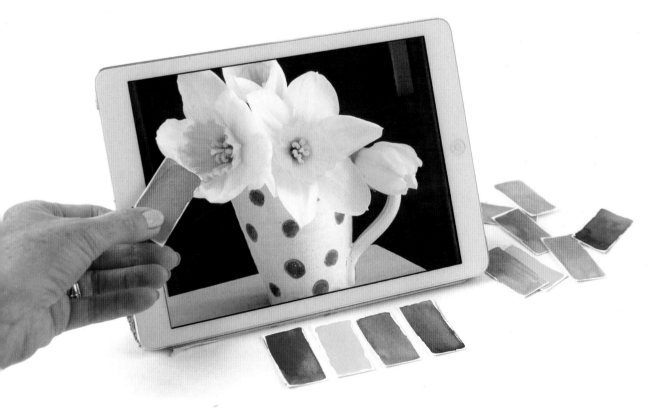

Tone

Tone refers to how light or how dark a colour is, and all colours have their own tonal values, which vary depending on the strength of the colour used. The amount of pigment used when mixing watercolour, coupled with the colours selected, will result in a specific tonal value. Add more water or pigment and the tone instantly changes.

Tonal values are extremely important in a painting. If the colours used within a painting are correct but too much water is used when mixing them, they become too diluted, and the painting will look very wishy-washy and flat. This is because the tonal values are not accurate, so everything appears pale.

It is always a good idea to include both light and dark tones within all paintings. Having the full contrast will improve the result – even if there is just a touch of the very darkest or lightest tones. Adding tiny dark stamens to the centre of a light-coloured flower, for example, can really draw the viewer to look into the centre, adding a sense of depth. Likewise, adding tiny light stamens, pollen or tiny highlights to the centre of a dark flower can do the same.

Bee on Blossom

20 x 21cm (7¾ x 8¼in)

This painting contains colours of similar tonal values. The only really dark tones are on the bee, so if you cover it with your hand, the painting has very few tonal contrasts and appears flat. When you lift your hand away, you'll notice how the dark tones on the bee change the entire painting, giving it depth and meaning.

The focus of the painting is on the bee which would almost disappear but for the dark bands on it.

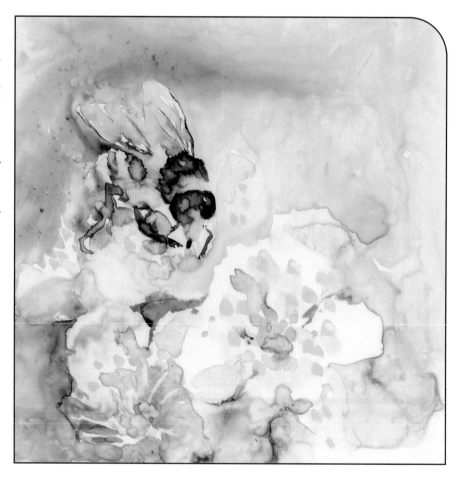

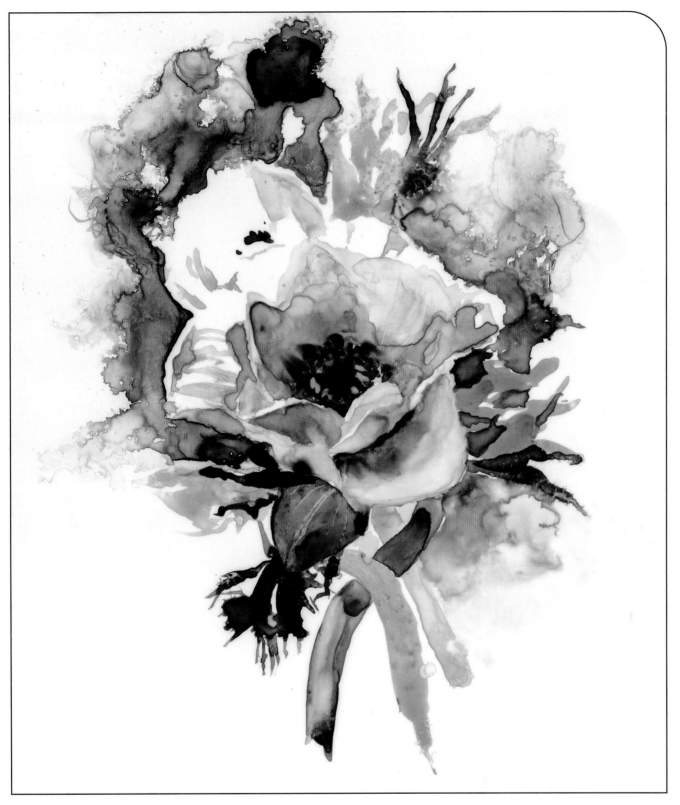

Sunlit Anemones

19.5cm x 25cm (8 x 10in)

This painting has high contrast colours, from the very dark tones in the centre of the flower to the lightest on the petals. All the tonal values in between these still feature but are not so apparent due to the intensity and extent of the strong contrasts used.

Tone scale

Being able to mix watercolour to create an accurate tonal value on your painting makes all the difference to the results you can achieve.

It can be so frustrating to mix the perfect colour – only to find it dries too pale when it is applied to the painting. You can usually add another layer to darken it once it has dried, but it is so much more convenient to mix the correct tone of colour to begin with, as it avoids unnecessary layers of paint which may muddy the result.

Make a tone scale

Understanding tonal values when mixing your colours is a valuable skill, so this exercise will help you practise and understand how to get the right tone every time. To start, draw five small squares on a clean piece of watercolour paper.

1 Mix a well of the darkest colour you are able by combining midnight green and the colour shadow. This mix should flow easily out of the brush, and not feel sticky or thick.

2 Use this black mix to paint the first square on your paper and leave it to dry. This is our dark tone. Label this '5' on your scale.

3 Separate half of the colour in the palette well and add a small amount of water at a time to it until it resembles the midtone above. Paint the middle square using this, then label it '3'.

4 To mix our dark-midtone, which we will label '4', add some of the initial mix to your midtone (3) mix to darken it, then paint the square between the dark and midtone.

5 Your light-midtone, or tone 2, should be made by adding water to your mix until it is paler than your midtone (3). Use this to paint the fourth square.

6 Add still more water to the light-midtone (2) and use it to paint the last box. This should be the palest colour (i.e. the lightest tone) you can achieve. Label it '1'.

7 Repeat this for all the other colours in your palette.

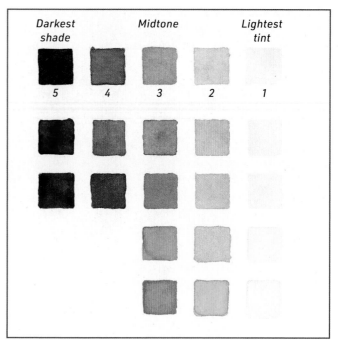

Darkest shade		Midtone		Lightest tint
5	4	3	2	1

Tone scale

This grid of small swatches shows full strength colours on the left, and increasingly lighter tones, created by adding more and more water, to the right.

Note that some colours are naturally lighter in tone than others. Here the two bottommost rows are sunlit green and wild rose. These are examples of colours that cannot be a darker tone than your midtone (tone 3), unless another colour is added to them.

Opposite:
Sunlit Rose
24 x 30cm (9½ x 12in)

This image has the tonal values indicated in different areas.

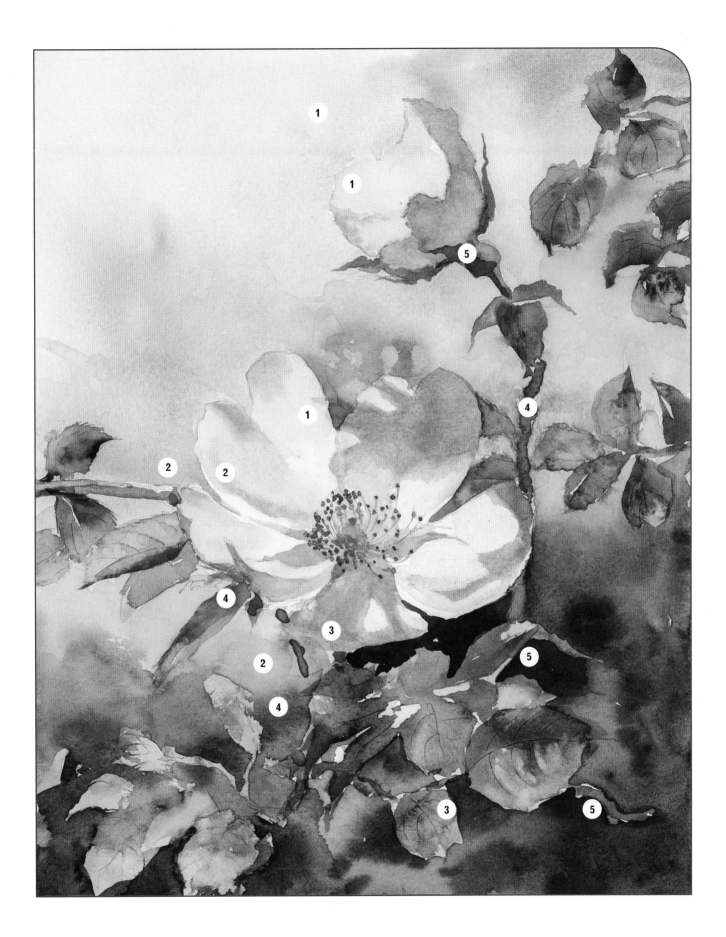

Tone checker

A tone checker can be used to ascertain the tonal value of any colour on a reference photograph. This will help you to mix the correct colour to apply to your painting. You can also use them to check that you have applied the correct tonal values to your painting. The colour doesn't matter: only the tone.

How to make tone checkers

Draw five 2.5 x 2.5cm (1 x 1in) squares on a piece of watercolour paper. Following the instructions for making a tone scale (see page 42), use a mix of midnight green and the colour shadow to paint five small squares in tonal values from 1–5. It is important that each colour fills the entire square.

Once these are completely dry, cut out the squares, then use a hole punch to make a small hole in the middle of each square. If you don't have a hole punch, make a small incision with a craft knife, then insert a pencil into the hole and turn it to enlarge the hole. Trim the reverse using a craft knife. The hole need not be a perfect circle, so don't worry if it is a bit wonky.

Tone checkers
The finished set of five tone checkers.

How to use your tone checkers with photographs

Move a tone checker over your photograph until the colour you wish to analyse is visible through the hole.

- If the colour visible in the hole does not look lighter or darker than the surrounding tonal square, then the tone you have selected is correct.

- If the colour you are analysing appears lighter in the hole than your tone square, change the tone square to a lighter one until they match.

- If the colour you are analysing looks darker in the hole than your tone square, change the tone square to a darker one until they match.

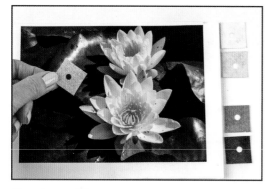

The midtone (3) checker is held up over an area of the photograph. The area visible through the hole is very obviously darker in tone than the paint on the checker, so this isn't the right tone of paint.

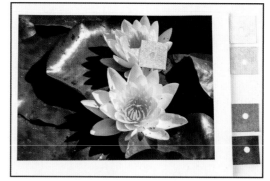

Here, the same checker is held over part of the flower – the hole is much harder to see, which means the tone on the image is close to that on the checker. This means you need a midtone (3) mix for this area of your painting.

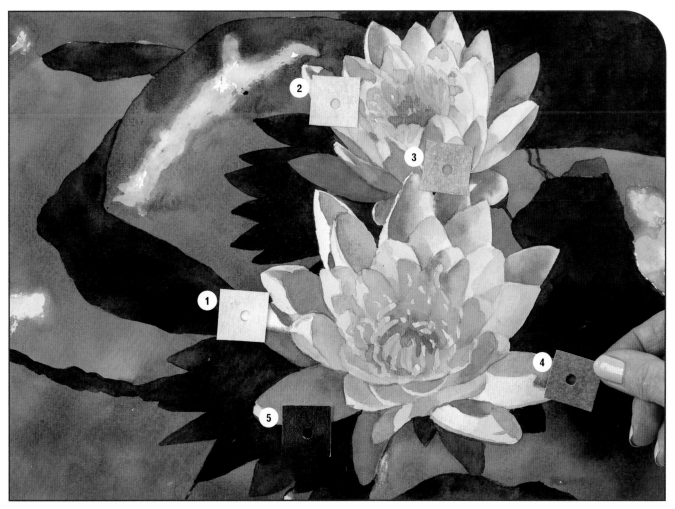

How to use your tone checkers with paintings

After checking the tonal values on the photograph, you can use the tone checkers together with your tone scale (see page 42) to help you mix your colours to the right tones.

Use the tone checkers to identify the right tone in the photograph, then make a mix of the right colour and tone in your palette, using your tone scale for reference. Once happy, you can use the mix to paint the area – remembering that any water you add, either in the palette or on the paper, will lighten the tone.

Once the paint has dried, use the tone checker over the painting, as shown above, to check that you've got the tones right – you can adjust any that are too light with additional layers.

Lily Pads
34.5 x 25 cm (13½ x 9¾ in)

Painted upon Bockingford 300gsm (140lb) Not surface paper.

The full tonal range is evident in this painting of lily pads in sunlight.

The colours I used were yellow gold, sunlit gold, autumn gold, shadow, sunlit green and midnight green. I used masking fluid to preserve the areas with the lightest tones.

White flowers

Watercolour paint needs to be diluted with water to create different strengths of colour, but pure white is best represented by simply leaving areas of paper unpainted. White sections can be as large as the flowers shown below or as small as the tiny gaps between the stems.

Plan where you want the white areas in a painting to be before you begin. Once an area of paper is painted, it can be difficult to remove that paint. Depending on the surface and paint you use, a stain can remain.

The outline for this exercise is number 12. Take some time to experiment with leaving white spaces on different papers and using different colour combinations. You could use the results to create cards or postcards.

White on natural paper

I used 300gsm (140lb) watercolour paper for this version of the exercise. Natural wood pulp paper absorbs the colour, so removing it completely can be difficult. For this reason you need to carefully paint the shapes adjacent to the area you wish to remain white, creating a lovely crisp edge to your white shape.

You may wish to use a Pointer brush if the shape is quite fiddly or detailed and you may wish to use your size 10 round brush for the larger areas. If you make a mistake and you paint the white area, don't worry. Wait until the watercolour has dried and then use your white gouache to paint over the top.

If there are smaller areas you wish to remain white, another option is to apply masking fluid to the intended white areas. See page 94 for the technique.

White on natural woodpulp paper
Using turquoise, midnight green, shadow and autumn gold, small sections of midtone colour were applied here, leaving white paper for the flowers and buds.

Outline 12

White on synthetic paper

The paper used for this version was very smooth and glossy, so the paint sat on the surface and was not absorbed. Had I needed to remove any paint, it could have been done so with ease from this surface.

This can be done immediately, while the colour is wet by using a thirsty brush (see page 66) to absorb any unwanted paint; or once the paint has dried, you can re-wet the area you want to remove and lift out the paint in the same way.

Because it is so easy to remove paint from synthetic paper, I would not usually use masking fluid on it. I might make an exception for fine delicate areas such as stamens or similar little dots, as masking fluid would be easier to use than trying to avoid painting tiny shapes.

White on synthetic paper
Here, the paint was applied to 255gsm (120lb) synthetic glossy paper.

How light affects tone

When sunlight shines directly onto the subject, the tonal contrasts become much stronger, so the whites appear brighter and the areas immediately adjoining those light areas appear darker. The shadow areas become much darker with fewer midtone areas, making detail less clear.

When a subject is not directly lit by the sun, more details can be observed in the shadow areas, the contrasts are less dramatic, and the midtones become more prevalent.

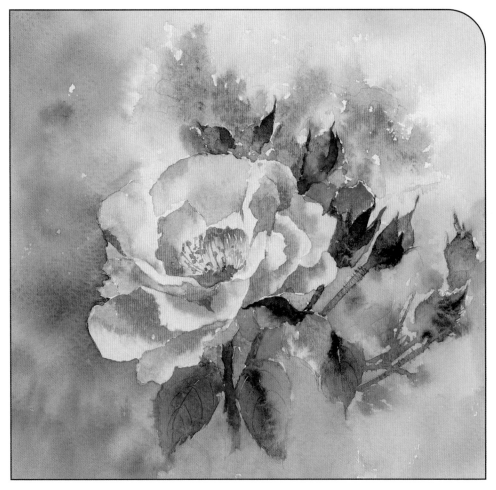

Rose on an Overcast Day
20.5 x 19.5cm (8 x 7½in)

Light falling on the petals here is soft, gradually changing the tonal value, which means some petals become less defined and appear to merge into one other. These are known as 'lost edges'.

If you hold your mid-light tone checker (2) over the top left-hand petal as it meets the green, you'll see that these sections are the same tonal value.

There are no dark tones (5) in this flower and only tiny touches of a dark-midtone (4). Most of the dark areas are midtone (3), heading toward the lightest tones (1).

Individual leaves are more defined in the midtone areas and the darker sections appear fewer.

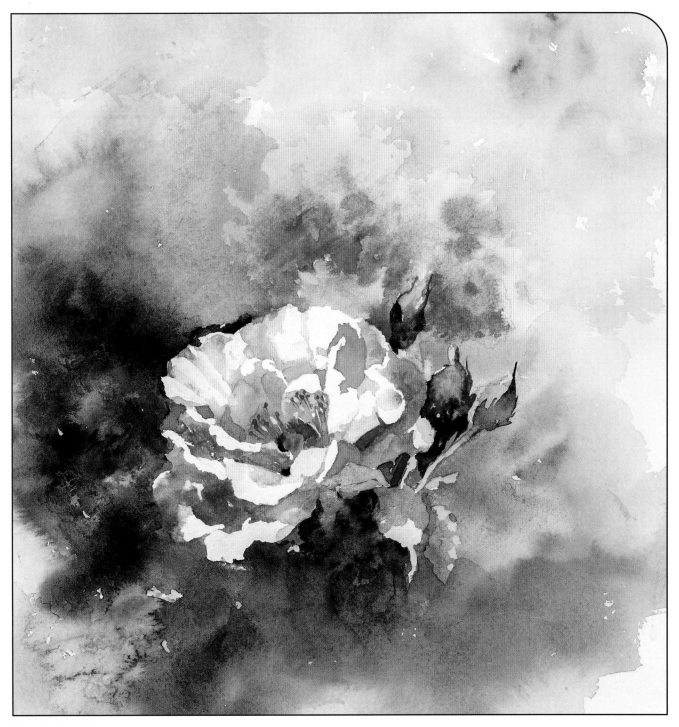

Rose in Sunshine

22 x 21cm (8½ x 8¼ in)

Crisp defined edges where the sunlit sections meet the shadows are used here to create the sharp contrasts. Each fold of a petal edge becomes highly focussed. Compare them with the dark sections, where edges and details can barely be defined. The dark areas are more suggestive, leaving more to the imagination.

Place your dark tone checker (5) over the background on the left of the rose, then place the dark-midtone (4) square onto the petals nearby. Notice how the petal sections in shadow are either dark-mid tones or moving towards the dark tone.

Mixing dark tones

Darks are so important in a painting. They add contrast and interest in the less defined sections. Having a range of dark colour mixing combinations will help you when selecting colours to use in any given painting.

When mixing, always begin with your darkest colour and introduce small amounts of the brighter colour to it. Using a flat palette is vital to be able to see how the colour alters.

Granulation

Notice how all the mixes which include ultramarine have a more textured result. This is caused by the granulating properties of the ultramarine pigment as the particles settle into the roughness of the paper, creating a textured effect.

It can be very useful knowing which of your colours granulate, as no matter what colour they are mixed with, they will always give a mottled result on textured paper.

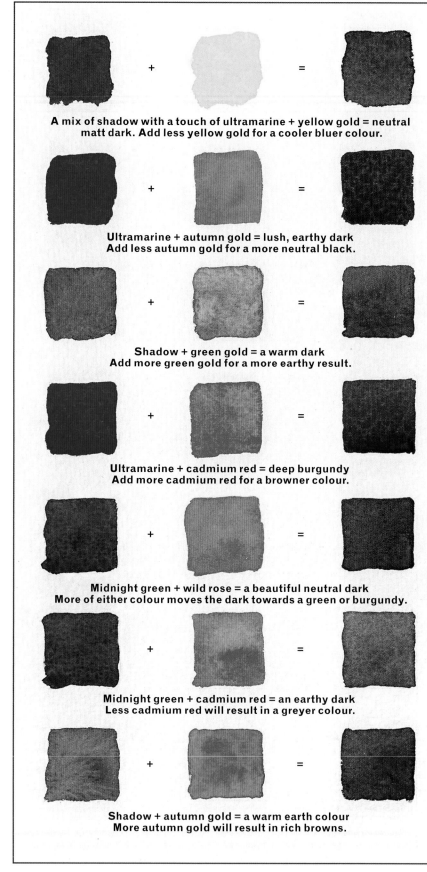

A mix of shadow with a touch of ultramarine + yellow gold = neutral matt dark. Add less yellow gold for a cooler bluer colour.

Ultramarine + autumn gold = lush, earthy dark Add less autumn gold for a more neutral black.

Shadow + green gold = a warm dark Add more green gold for a more earthy result.

Ultramarine + cadmium red = deep burgundy Add more cadmium red for a browner colour.

Midnight green + wild rose = a beautiful neutral dark More of either colour moves the dark towards a green or burgundy.

Midnight green + cadmium red = an earthy dark Less cadmium red will result in a greyer colour.

Shadow + autumn gold = a warm earth colour More autumn gold will result in rich browns.

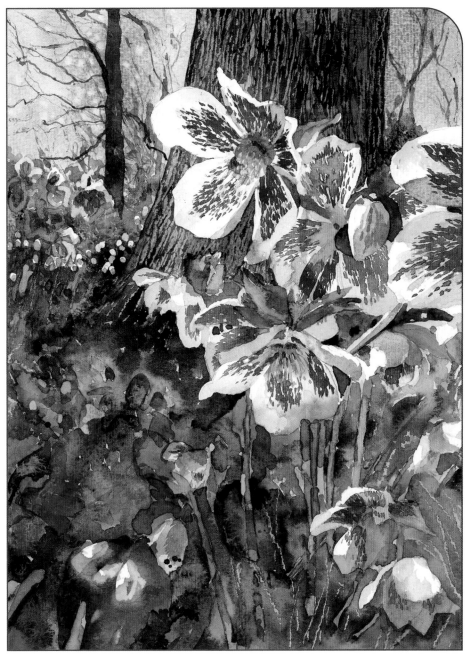

Woodland Walk

24.5 x 32.5cm (9¾ x 12¾in)

Although the focal point of this painting is the group of hellebores nestled beneath the tree, much of this painting consists of mid-dark tones, so a variety of dark colours needs to be mixed in order to make the painting interesting and suggest a complex undergrowth.

Confidence in mixing lovely dark colours will help to make your paintings more convincing.

Greens

Greens can vary so much. Even within the same plant, the foliage bathed in sunshine can appear almost an acid green verging towards yellow gold, while greens in shadow can seem almost blue.

Mixing this variety of greens may seem difficult, but you can make some wonderful greens even with a very limited palette, especially if you have ready mixed greens as your starting point.

When looking at the green you wish to mix, decide which of the three ready-mixed greens is the nearest to it. Next, introduce a little of a different colour to the green to alter it. Adding a small amount will alter it just a little; while adding a lot can make the green totally different – as this exercise shows.

Mixing greens

Getting to know the greens in your palette and how to alter them is a vital skill for painting flowers. This simple little mixing exercise will help you to understand how you can use your ready-mixed greens to make things easier. You can draw the shapes freehand, or download the outline from Bookmarked Hub (www.bookmarkedhub.com) to help as described on page 16.

Each of the leaf clusters begin with the same green, introducing a contrasting colour at the tip and blending the colour in the centre area to show how the colour mixes.

The intention is not to make a beautiful realistic leaf; but rather to make an attractive study that contains lots of useful information on the variety of colours we can create by adding different colours to the same green.

Here, yellow gold is being added to a basic green – midnight green.

Sunlit green base

I have mixed sunlit green with wild rose, midnight green, autumn gold, turquoise, ultramarine and bluebell.

Mixing sunlit green with the yellow gold or sunlit gold would not alter the green sufficiently.

Country olive base

To country olive I have mixed yellow gold, sunlit gold, autumn gold, turquoise, ultramarine and bluebell.

Midnight green base

To midnight green I have mixed yellow gold, sunlit gold, autumn gold, turquoise, ultramarine and bluebell.

Sweet Mock Orange

It can be refreshing to paint flowers growing naturally, rather than cut flowers positioned as a subject to paint. These flowers cascade downwards, inviting the insects hovering beneath to pollinate their centres, so we want our painting to reflect that.

In this project, you will learn how to drop in areas of colour. The photograph we will be using as our reference was taken on an overcast day, so all lights and darks are subtle. Our darkest tone will be the background, which we build up in sections, so don't worry – you don't have to try to paint it all at once.

You will need:

Paper: 37 x 33cm (14½ x 13in) Bockingford Not surface 300gsm (140lb) watercolour paper

Brushes: two Pointer brushes, two size 10 rounds, Golden Leaf

Paints: yellow gold, sunlit green, ultramarine, wild rose, white gouache

5B pencil and putty eraser

Source photograph

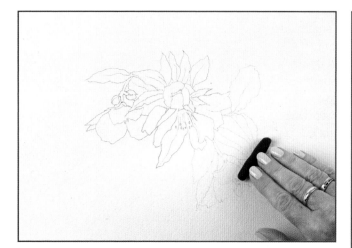

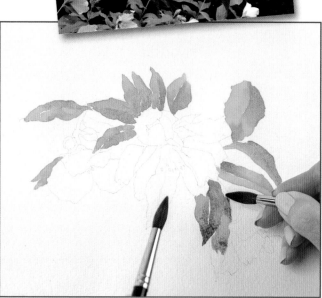

1 Transfer the image from outline 13 to your watercolour paper, as described on page 17, then gently use the putty eraser like a rolling pin to soften the pencil lines. Next, prepare a well with separate pools of ultramarine and sunlit green. Allow the two pools of colour to meet, but don't mix them together completely.

2 Starting at the top left and working round, paint the leaves using two size 10 brushes, one for the blue, one for the green, so you can swap between them quickly and bring wet colour to wet colour on the surface without ending up with muddy mixes. Paint one leaf at a time, and work your way along. Use more blue where you want to suggest shadows.

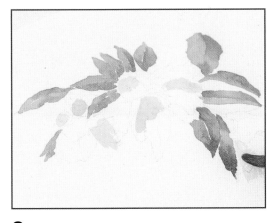

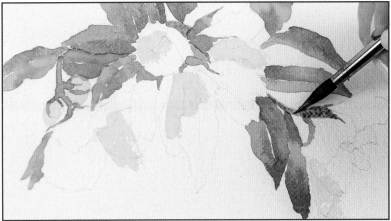

3 Once dry, rinse the size 10 brushes, then use one to paint in all the flowers and buds with a really bright yellow gold. Allow to dry before continuing.

4 Paint the stems and bud casings with sunlit green using the Pointer brush. While the stems are wet, touch in a little wild rose. This will turn the colour a pinky-brown.

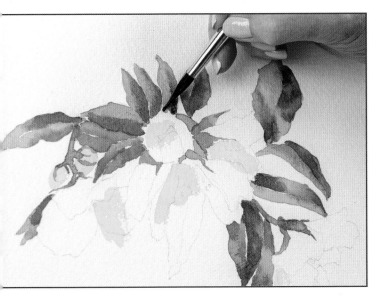

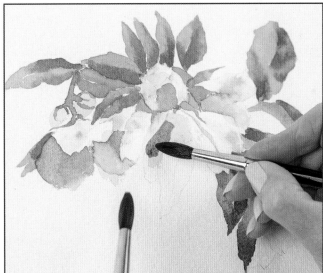

5 Once dry, consider the tone of the leaves. To deepen the shadows and prevent leaves from looking flat, you can wet the whole leaf with clean water, then use the Pointer to drop in your darker tone – in this example, ultramarine. It's important the leaves are completely dry before rewetting, or you'll disturb and move the underlying pigment, resulting in a blotchy finish.

6 You've now balanced the tones in the leaves, so we can move on to the flowers. Paint in the shadows on the flowers using a blue-grey mix of ultramarine with a touch of yellow gold. Make sure you mix enough to work across all the flowers, and use two size 10 round brushes. Here, one is used to apply the paint, adding it to the darkest sections first; and the other is loaded just with clean water, and used to soften and pull the paint.

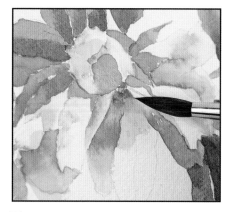 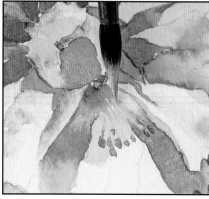 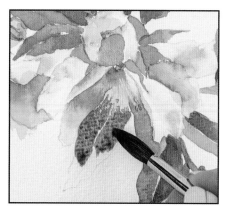

7 Add a small touch of wild rose to the centre of the central flower head in the same way, using a Pointer brush, then allow the painting to dry. Tone down the pink area by adding a little of the blue-grey mix over the top, and drawing it out with clean water.

8 Use an orange mix of wild rose with a touch of yellow gold to add the flower pollen with a Pointer brush. Once dry, dilute gouache to a consistency similar to double cream (US heavy cream), then add a little of the orange mix to it and use this to paint in the stamens.

9 Using the leaf combination from earlier (ultramarine and sunlit green in separate pools), paint in the leaf below the central flower. Use the Pointer to work carefully around the stamens and pollen, then use a damp size 10 round brush to pull the colour out.

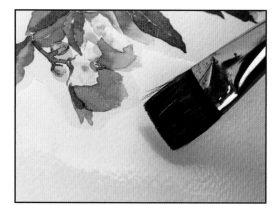 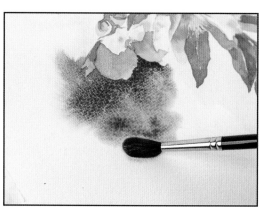

10 Once completely dry, it's time to start on the background. Prepare plenty of paint before you begin. You'll need a large pool of ultramarine, and smaller amounts of yellow gold and wild rose. Use the Golden Leaf brush to wet a section of the background area with clean water, so that the wet paint will flow into the space. Leave a 1cm (½in) border around the painted image.

11 Apply the ultramarine paint using the Pointer brush into the dry border area, then switch to a damp size 10 round brush and draw the paint outwards into the adjoining water, letting the colour bleed away. Add different colours from your prepared palette wet in wet, allowing the colours to bleed into one another within the wet area.

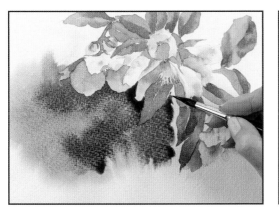

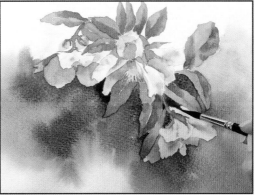

12 As you approach the edges of the pre-wetted section, wet the next area of background with clean water and the Golden Leaf brush, then carry on as before.

13 Continue working around the painting in this way, varying the colour and tone – a few lighter or darker background areas add interest. Swap to the Pointer for narrow gaps and small areas as you come to them. There's no need to pre-wet the enclosed areas like this.

The finished painting

Going further

This painting builds on the skills you practised in the project on the previous pages – it's perfect if you'd like to practise the colours and techniques described earlier on a more ambitious and rewarding painting. The notes below will help to guide you.

- After transferring the image, start by painting the leaves and stalks at the top of the branch. This establishes the directional movement across the page and develops the colours within the project.

- Mixing various combinations of country olive and ultramarine, paint the leaves, diluting the mixes with water and dropping in more colour where necessary. Wherever there is a need to brighten an area, yellow gold can be dropped in using a Pointer brush.

- It is important to paint the stalks at the same time as the adjoining leaves, so that the colours merge, suggesting the leaf is attached to the stalk.

- Where the stalks appear pink, drop in wild rose to the wet green paint and allow it to flow along the stem.

- Once the first few clusters of leaves are painted, use a very dilute wash of yellow gold and a size 10 round brush to paint any sections of the flowers and buds which appear to have a hint of yellow. This will give a warm glow to the final painting in these sections. Once this has dried, paint all the remaining leaves.

- The next stage is painting the shadows on the white flowers. Using ultramarine and a touch of yellow gold, paint the shadow areas placing the colour in the darkest sections first and merging this with water using a second brush. If the colour seems too pale, drop more colour into the dark section.

- Once dry, add the flower centres, using the Pointer to add sunlit gold for the pollen heads, then adding a little gouache to the colour for the stamens.

- The dark background can now be added. Use combinations of ultramarine, country olive and shadow, and begin with the underside of the first flower in a very deep wet colour. Wet the adjoining section of paper using the Golden Leaf brush, then work outwards towards the empty space. The paper should not be pooling with water, but just wet enough so that the paint seeps into it avoiding a dried edge. More colour variations can be added to the damp paper and moved with the brush.

- Work all round the composition in the same way, finishing back at the top of the painting where you began. This must dry completely before moving forward.

- Finally, add the finishing touches. Use autumn gold darkened with a touch of shadow to paint the darker pollen heads, and a combination of wild rose and shadow for the mauve flower centres.

- Use your tone checker and darken any shadows that need adjusting.

Sweet Mock Orange (*Philadelphus coronarius*)
37 x 33cm (14½ x 13in)

The outline is also available to download free from the Bookmarked Hub: www.bookmarkedhub.com, as described on page 16.

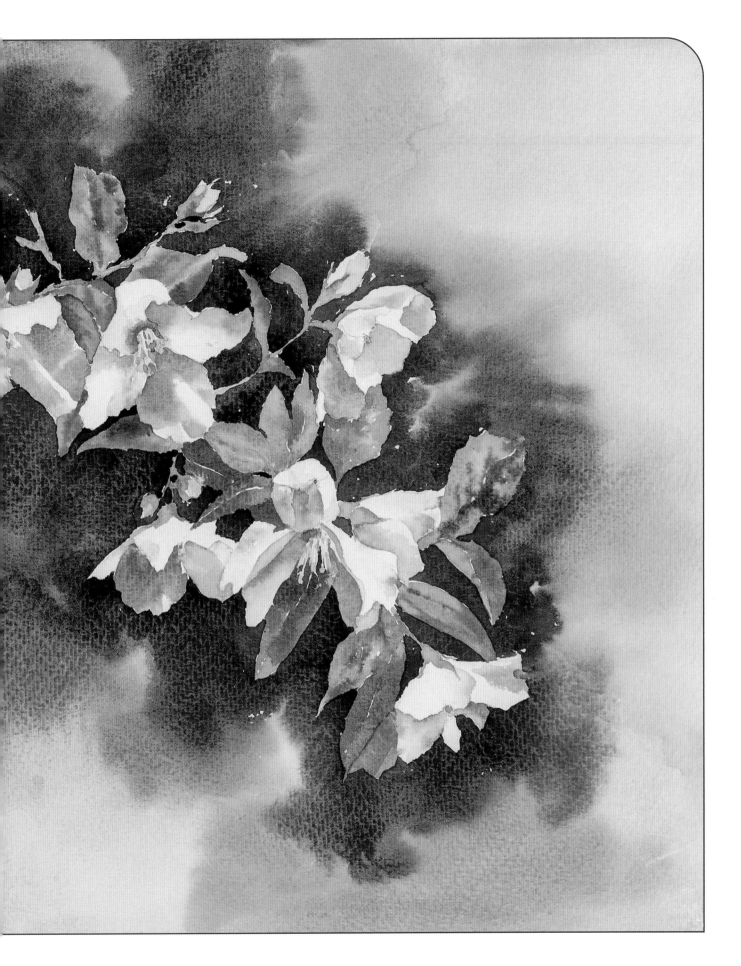

Adding an underpainting

The example on the previous page built on the smaller study in the project. This painting takes things another step forward again with an underpainting – but don't worry; if you have painted the project, you'll have all the skills you need for this, if you want to give it a go yourself.

I wanted to give the impression of these flowers cascading downwards in a complex mass of leaves, open flowers and buds. For this more complicated composition, my approach was different in that I began by wetting the paper all over using the Golden Leaf brush, then dropped in pale colours using turquoise, sunlit gold, sunlit green and wild rose. This is 'underpainting', which adds to the final depth of the painting and can be built up in multiple layers.

Once this had dried, I painted the background stalks and pink flower centres, as well as the leaves, adding ultramarine to darken my colour palette.

The background was then added, after which I painted the shadows on the flowers, darkened some of the leaves and adjusted the tonal values on the stems. Any tiny sections that remained in between the leaves were then painted using the dark background colour.

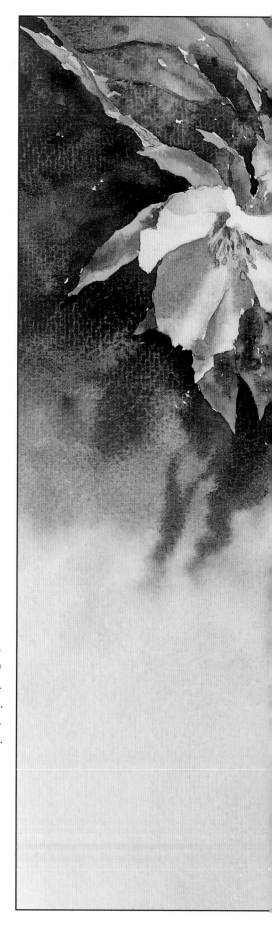

White Cascade

39 x 32cm (15 x 13½in)

The colours used here were sunlit gold, turquoise, wild rose, sunlit green and ultramarine blue.

The outline is also available to download free from the Bookmarked Hub: www.bookmarkedhub.com, as described on page 16.

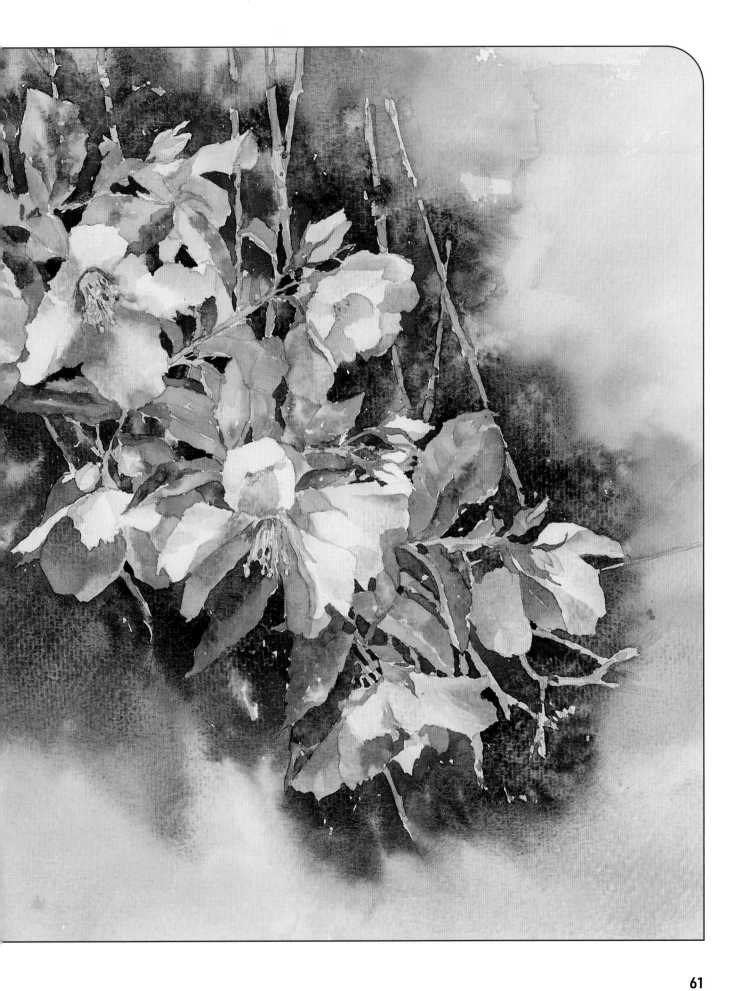

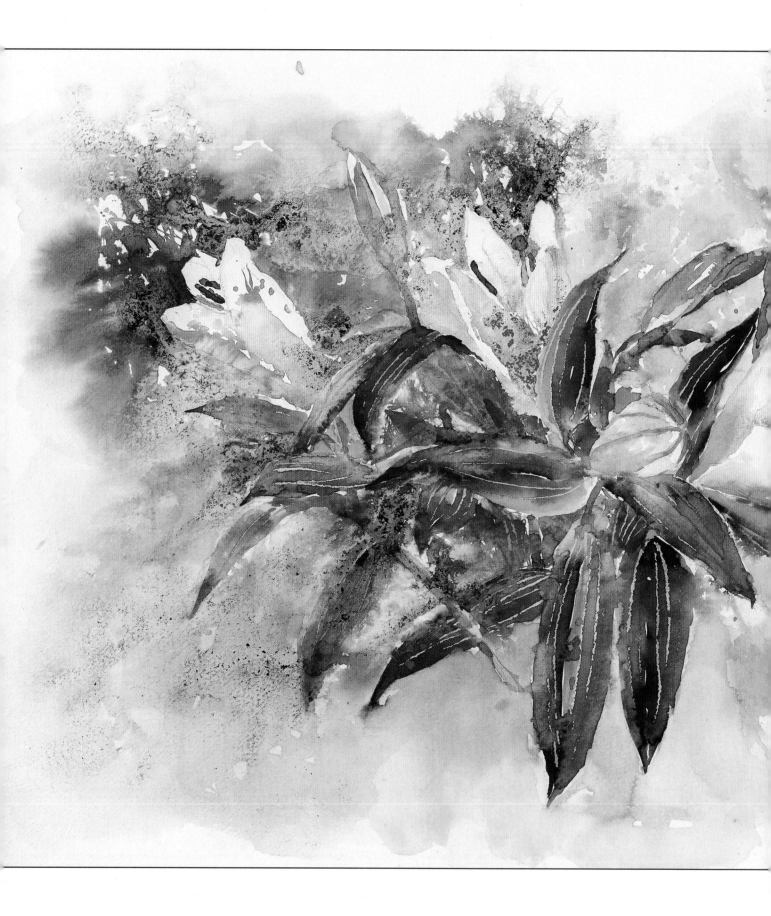

More ideas and techniques

As your confidence in using watercolour builds and your drawing skills improve, you are likely to want to push the boundaries a little, work a little wetter, and take a few risks. In order for these risks to pay off, we need an understanding of what happens when we use more water, more watercolour and how we adapt to situations as they occur. Pushing boundaries is a way of advancing your skills and understanding and in doing so you will get far more from your watercolours.

One of the key phrases I use about the consistency of watercolour is 'the wetter the better, without it pooling' – but even if sections of your painting pool where you have been a little over-enthusiastic with the water, this is no bad thing. As you practise, you will get the feel of how absorbent your brushes can be, the amount of liquid they hold, and how to control that liquid as you release it onto the paper. It will take time and understanding, but you will find yourself becoming a more intuitive painter, able to adapt to situations with ease.

In any case, there are several ways you can lift excess liquid. You may also want to know how to create lovely soft edges, blend colours on the paper, and create textures to add more interest to the background areas of your paintings.

It is now time to extend your skills and take more risks.

Scented Lilies

52 x 34cm (19 x 13½in)

The directional lines on the leaves are created using a palette knife (see page 110) and the lovely mottled texture using pigment inks (see page 114).

Soft edges

Creating soft edges using watercolour is one of the most important techniques to master. The key is learning to judge how wet your brush needs to be when applying water to an area of wet paint.

When the brush is very wet, the water will flow into the wet colour the moment you touch the paper. By instead placing the brush onto dry paper next to the wet area, then approaching and touching the wet colour with your brush, you can better control how the colour moves into the wet section of paper.

1 Wet the entire petal (or area you're interested in) with clean water.

2 Introduce a small amount of strong paint to the area furthest from the soft edge you want to create. From here, don't touch it. The less you move the paint, the better. Let the pigment float in the water and diffuse naturally. This is why the paint needs to be strong initially – it's going to be gradually diluted by all the water on the surface.

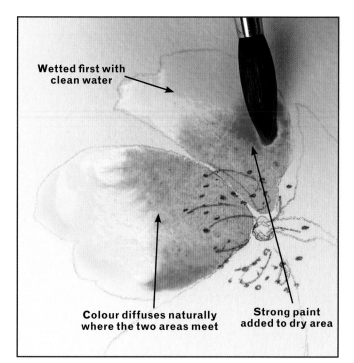

Here, the outside of the petals have been wetted, and the insides left dry. Add the paint to the dry insides for bold, strong colour, then gently draw it up to the wet area, allowing the paint to just 'kiss' the wet area before lifting the brush away. The pigment will diffuse into the wet area for a smooth blend.

The amount of movement the pigment makes will vary depending on the surface you're using. More absorbent papers will inhibit movement, while less absorbent papers will let the paint flow freely – sometimes uncontrollably.

The amount of water you use, and how long you wait before applying the paint, will also affect things. Here, three petals on the same surface (Bockingford Not surface watercolour paper) have been painted with varying amounts of water but the same amount of paint each time. The leftmost was drenched, and the paint added immediately. The central petal was painted with a moderate amount of water, and the paint added after a few seconds. The third was painted with little water, and the paint added only after the gloss of the water had gone.

Tip

Using two brushes, one for colour and one for water makes this process much easier.

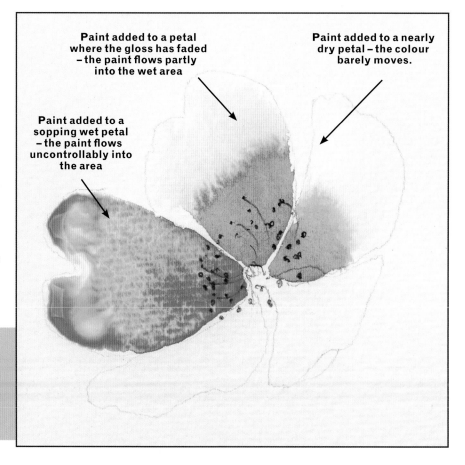

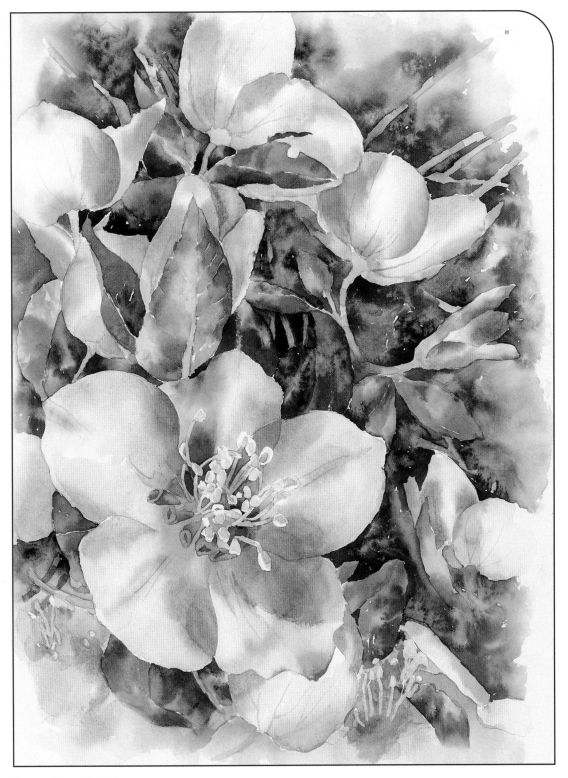

Lenten Rose Hellebore

27 x 39cm (10½ x 15½in) on watercolour 300gsm (140lb) Not surface paper

After masking out the flower centres, I painted the flower petals, softening the colour with water from the outer edge towards the centre. The leaves use this same technique: softening with either water or a very dilute colour and allowing the colours to gently merge. I used the colours turquoise, bluebell, wild rose, midnight green, country olive, sunlit green and sunlit gold.

Using a thirsty brush for control

Working with excess wet paint creates lovely loose effects, particularly when we allow the colours to gently run into each other. However, there are times when we want to remove excess liquid from the surface. This is another opportunity to use a 'thirsty brush', as described on page 22. Besides lifting out entirely, you can use this technique to shape and control loose washes.

Tip

Avoid squeezing the brush between your fingers: this can make the brush too 'thirsty' and absorb paint like blotting paper – perhaps more than you would wish.

1 Create a thirsty brush by rinsing it and running it across kitchen paper to draw out excess liquid.

2 Test that the brush is thirsty by pressing the tip. It should remain slightly curved, as shown, and not spring back into shape.

3 To use the thirsty brush, lightly touch the top to the wet paint you want to draw up (see above), and allow it to be absorbed into the tip of the brush. You can move the brush gently to pick up more, as shown to the right.

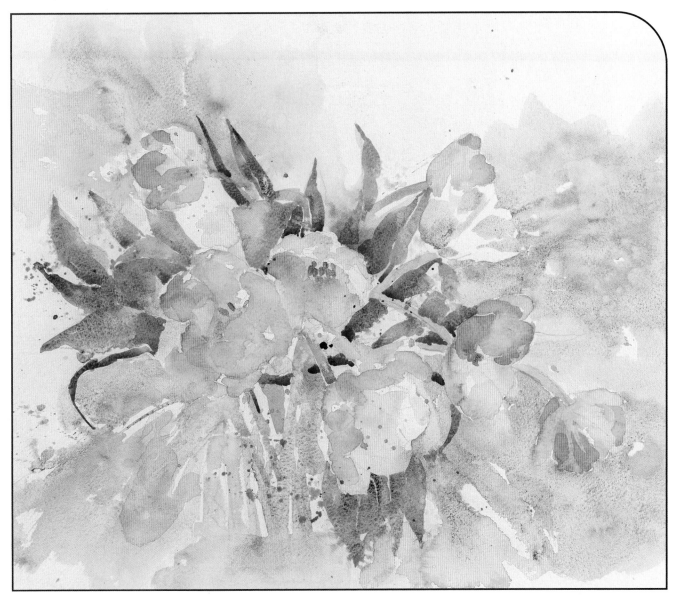

Open Pink Tulips

55 x 38cm (21¾ x 15in)

Using a well-loaded brush and allowing sections to run into one another is an exciting way to experiment with watercolour. It is one of the best ways to understand how to control the paint, lifting it when necessary and adding more when you want it to flow.

Using kitchen paper

Pooling paint can swirl about, creating wonderful effects which can be controlled by drawing up excess liquid with the corner of a sheet of kitchen paper. You can also use this surprisingly versatile material to create quick textures.

Working on Yupo synthetic paper allows us to work wetter than we would be able if using traditional watercolour paper, but these effects are achievable by using either.

Tip

The darker the pigment used, the more dramatic the texture created.

Lifting out with kitchen paper

When paint pools, you can use the corner of kitchen paper to draw up excess liquid and prevent it pooling. Simply touch the corner to the area you want to draw up and allow the paint to creep up.

Texture with kitchen paper

Crumpled kitchen paper or any absorbent soft paper can be used to create lovely, mottled effects by gently touching the surface of the wet paint with the paper.

The amount of pigment lifted depends on the amount of pressure applied with the kitchen paper. A gentle pressure – barely touching the surface of the paper – will result in very subtle textures, while a firmer pressure can result in specific shapes.

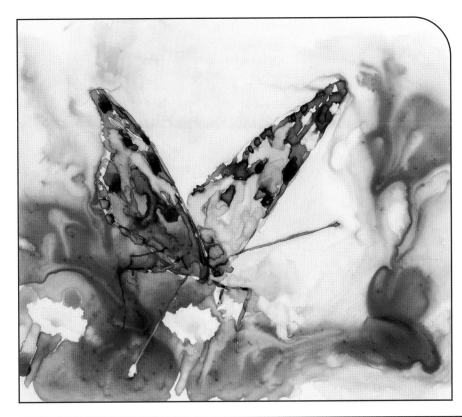

Butterfly on Bougainvillea Flower

17 x 14cm (6½ x 5½in)

Painted on Yupo synthetic paper, I wanted the butterfly in focus and the background more suggestive. I used very fluid paint in the background section, which allowed the paint to move more freely. Excess liquid was then gently absorbed using the corner of kitchen paper.

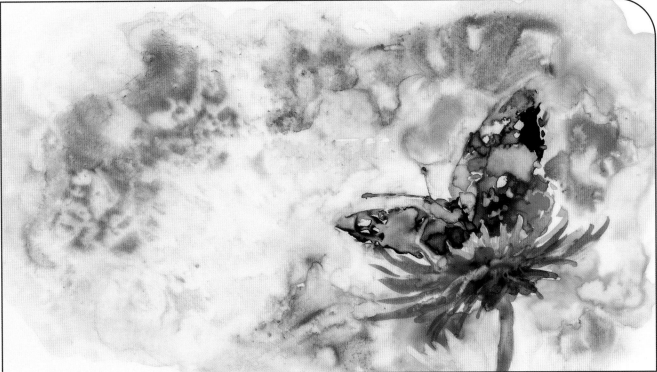

Butterfly on Aster

17 x 10cm (6½ x 4in) on Yupo

The butterfly on the aster was allowed to dry before I painted the background. This allowed me to safely create the textured effects without removing any paint from the main subject. This simple technique results in an in-focus subject (the butterfly) against an out-of-focus background, leaving the background somewhat to the viewer's imagination.

Creating texture and interest

Using salt to absorb pigment from a wet surface

All types of salt will absorb watercolour pigment and potentially produce lovely results. The paint needs to be wet, and the darker the pigment, the more dramatic the effects appear.

1 Sprinkle salt into an area of wet paint. Whether using crystals or grains, one tiny speck of salt will produce a starburst effect, so use salt sparingly.

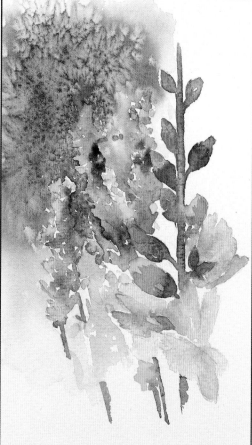

Tip
Only wet areas of paint will be affected; any adjoining dry areas will not. This makes the technique ideal to use for small sections between leaves or flowers.

2 Once the salt is sprinkled onto the surface of the painting, it needs to be left to dry. After this, the grains can simply be wiped away using a dry brush to reveal the effect.

Texture with the Golden Leaf brush

Applying water to a wet or damp painted surface will result in diluting the colour – but also gives the potential for creating textures. The Golden Leaf brush can be used for soft stippling: one tap of the brush on the wet surface is sufficient to agitate the wash and create a mottled effect. The more water retained in the bristles, the clearer and larger the marks created. Experiment with squeezing out more or less water before separating the hairs.

1 Dip the brush in your water pot, then gently squeeze out the excess water. You want the hairs to retain some moisture – not as dry as a thirsty brush (see page 66).

2 Tap the end of the brush on the palm of your hand to separate the hairs as shown.

3 Holding the brush upright, lightly tap it on the wet surface. This will release tiny amounts of water onto the surface, which will expand and create a textural effect.

Velvet Hellebores

43.5 x 33cm (17 x 13in)

Table salt was sprinkled onto the wet green background resulting in a fine texture. Larger crystals of rock salt were dropped on the dark maroon leaves, creating larger textural bursts.

The wet Golden Leaf brush was used on the lower leaves on the left as well as the outer edge of the soft-focus flower creating softer textures.

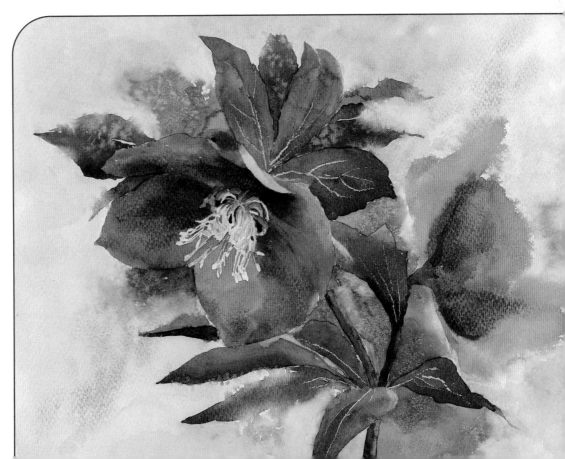

Majestic Magnolia

In addition to dropping in the colours, for this beautiful subject we are going to overlay colours to add depth to the painting, allowing the wash of watercolour underneath to dry before applying a second layer. Adding thin transparent layers, or glazes, in watercolour will alter the appearance of the colour previously applied. **D**epth and intensity of colour can be built up in this way.

We will be adding textures to our background but be prepared to adapt your painting depending on the wetness of your work. You may need to lift a little liquid if you feel your paint is pooling or you may wish to drop more in if you feel you need to.

All the skills you need have been tackled on the previous pages, so be confident: you can do this!

You will need:

Paper: 38 x 28cm (15 x 11in) Bockingford Not surface 300gsm (140lb) watercolour paper

Brushes: two Pointer brushes, two size 10 rounds, Golden Leaf

Paints: yellow gold, country olive, midnight green, shadow, autumn gold, ultramarine

5B pencil and putty eraser

Source photograph

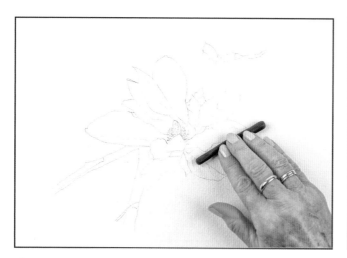

1 Transfer outline 14 to your watercolour paper as described on page 17, then gently use the putty eraser like a rolling pin to soften the lines a little.

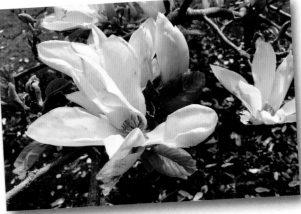

2 Use a size 10 round brush to add very dilute yellow gold wherever you see a bright colour – this includes the petals of the flower heads and some of the leaves. Next, use very dilute shadow to position where the branches will be. This is a good habit to build for more complicated pictures, as it establishes a frame of reference.

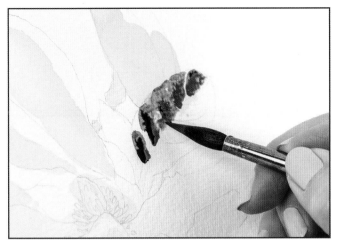

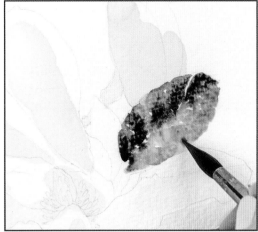

3 Create the impression of mottled leaves by painting small marks of country olive with the tip of a size 10 round brush, leaving gaps for the leaf veins. On the shadow sides of the leaves, swap to a Pointer and touch in midnight green, pulling the colour out.

4 Paint the lighter side of the leaves in a similar way, by simply pulling the country olive out towards the central vein.

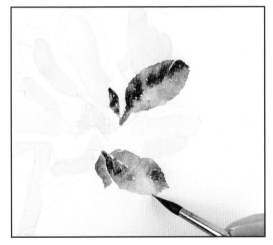

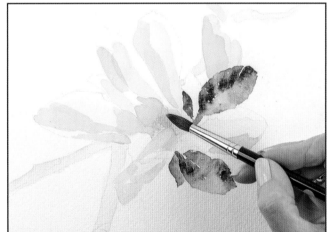

5 Paint the other leaves in the same way, varying the tone. Where the leaves are in the sunlight, add more water, and where they are in shadow, drop in more midnight green.

6 Using the size 10 round brush, add a tiny touch of country olive to yellow gold in a palette well. Use this to add a little depth to the magnolia petals. Make sure that you retain some areas of clean white paper where the petals are in direct sunlight. Add some pure yellow gold in the centre of the main flower head.

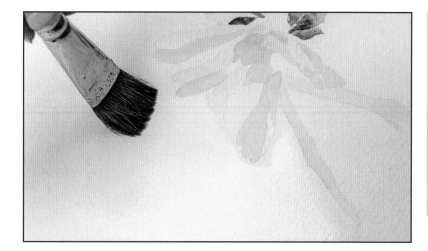

Tip

When the flowers are very pale and the background very dark, you may find the tones easier to work out if you establish the background first then add the shading to the petals, rather than the other way round. There's no right way of working, so experiment and find what works for you and your painting.

7 For the background, prepare large wells of country olive, midnight green and a smaller amount of yellow gold. Using the branches as natural barriers to divide the background into sections, use the Golden Leaf brush to wet the surface of the first section with clean water, leaving a dry gap between the image and the wet area.

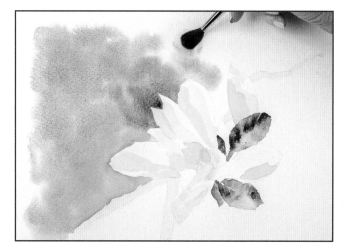

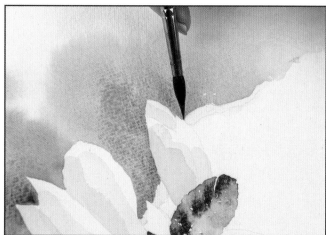

8 Use the size 10 round brush to paint a varied background using country olive and midnight green. As you work, try to keep the tonal values in the background quite light, to create an airy feeling, full of sunlight.

9 As you reach the branch, aim for a hard edge. Because the branch spans the gap between the flower and the edge of the painting, forming a complete break in the background, you can safely pause at this point. It's a good chance to fill in any difficult angles, corners or enclosed areas in the part of the background you've just worked.

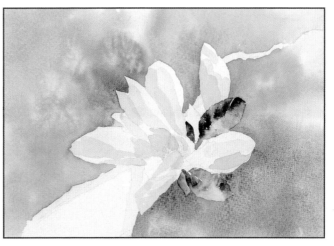

10 While the paint is still wet, use the Golden Leaf brush to add some texture, as described on page 71. The water transferred from the Golden Leaf will only affect wet areas, so you can work partially over the dry flowers without affecting them, allowing you to create background texture that comes right up to the flowers.

11 Continue painting the background in the same way. When you start the next section, match or echo the tones and colours used on the other side of the branch, or it will look unnatural. Note that while you should keep areas similar across sections, there's no reason you can't vary the tone and colour within sections. Here, I've dropped in some touches of shadow for interest, using the Pointer brush.

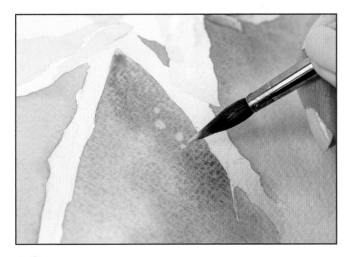

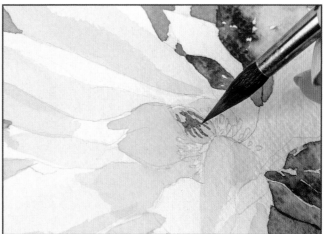

12 Paint the final section, and wait until the gloss of the wet paint has faded before using the Pointer brush to add yellow gold touches to suggest background daisies. Waiting a little bit will ensure that the paint doesn't run too far. Take the paint straight from the pan, too – don't dilute it at all.

13 Use the Pointer and a mixture of country olive and midnight green to paint the centre of the flower. Create the impression of the tiny stamens in the centres through negative painting, leaving small lines.

Tip
If you accidentally create a green blob, don't worry – once the area is dry, you can add a little white gouache to your golden yellow and paint the stamens in as positive shapes instead.

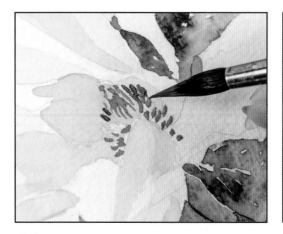

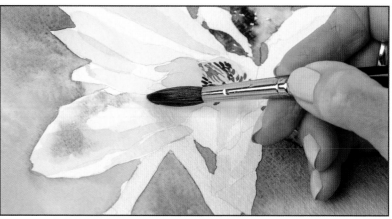

14 Use the tip of the Pointer brush to to touch in the orange parts in sunlight using fairly strong autumn gold, then use a mix of autumn gold with a little shadow to paint the shaded details of the flower centre.

15 Once dry, add a touch of autumn gold to a pool of ultramarine and start to develop the shadows on the petals. It's worth making plenty of paint before you start, to ensure you don't run out halfway through. Dilute the paint a lot, and use two size 10 rounds – one to add the paint in small marks on dry paper, and one with clean water to invite the paint to move into position softly.

Tip

Don't use the brush dripping wet, or you'll introduce too much water and the paint will run uncontrollably. Tap off the excess on the edge of your water pot before using it.

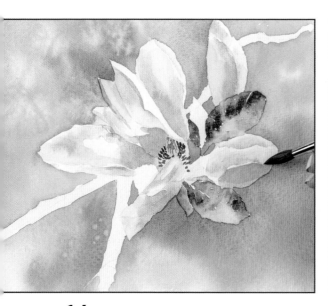

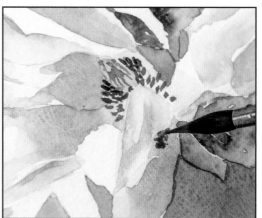

16 Continue adding the shadows, paying careful attention to the reference photograph to ensure you place the shadows correctly. Where the petals in the photograph are bright white, don't apply any paint at all – let the clean white paper stand for bright gleaming sunlight.

17 As you put the shadows in, you'll probably spot glimpses of leaves or other details that you've missed. This is a perfect opportunity to add them in. Here, I've added a partially hidden bit of the centre, using the techniques and colours from step 14.

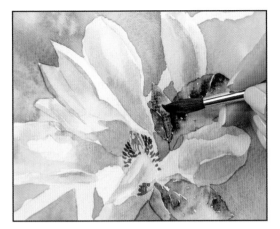

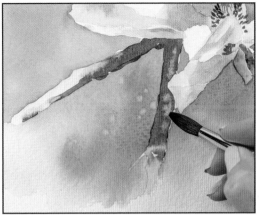

18 Add shadow and a tiny touch of autumn gold to the blue mix remaining on your palette, and dilute to make a mix for the branch. Use the size 10 to paint in the small part of the branch behind the petals.

19 Paint the larger parts of the branch with the same mix, leaving areas in sunlight as clean paper. If you want to try adding some texture to the bark, try lightly touching the damp tip of a clean size 10 to the wet paint.

The finished painting

To finish, lightly dab very dilute yellow gold over the leaves to re-introduce some sunlight and help them pop out from the background.

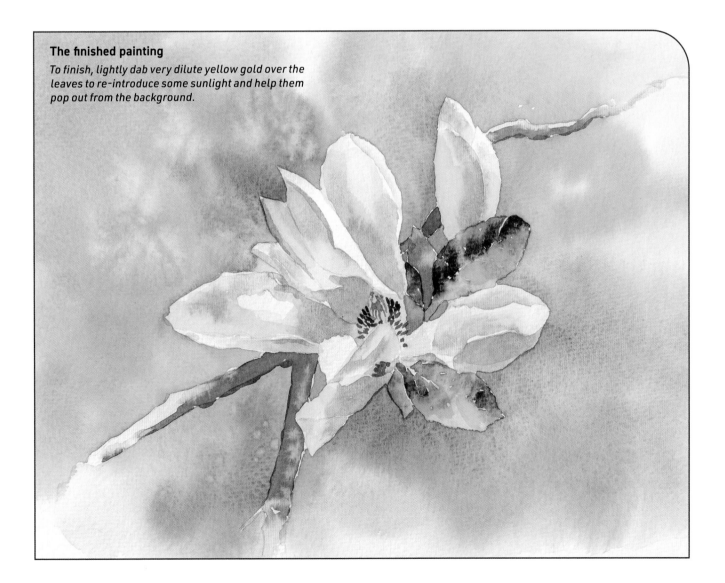

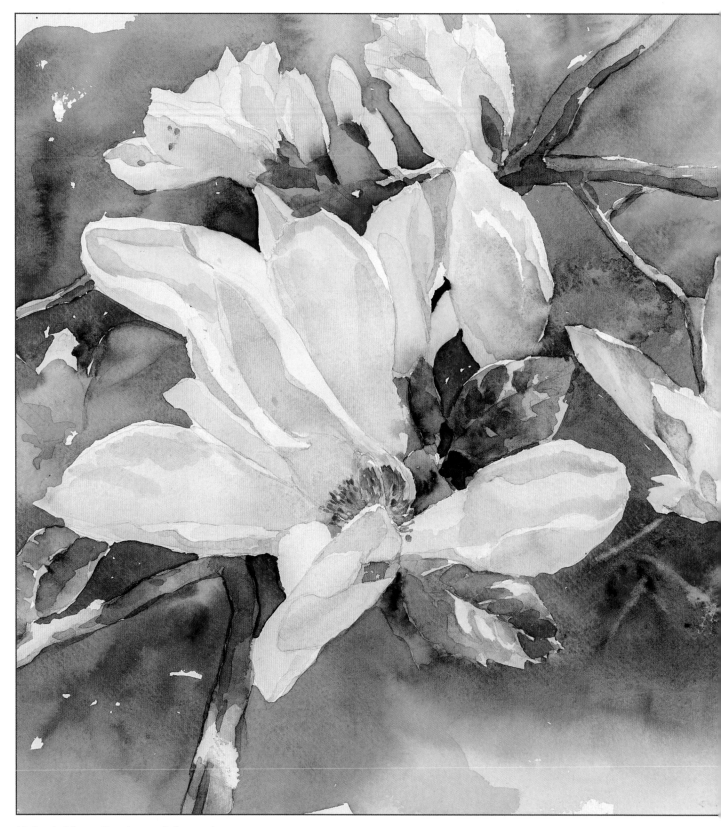

Majestic Magnolia – beyond the study

37 x 33cm (14½ x 13in)

The outline is also available to download free from the Bookmarked Hub:
www.bookmarkedhub.com, as described on page 16.

Going further

This painting builds on the skills you practised in the project on the previous pages – use the colours and techniques there together with the notes below.

- After transferring the image, position the flowers and leaves using very dilute yellow gold, then add the branches using a dilute shadow and the size 10 round brush.

- Using combinations of country olive, midnight green and water, paint all of the leaves and bud casings using the techniques explained in the project. Brighten areas by dropping in yellow gold using a Pointer brush.

- Once the leaves have dried, use a dilute wash of sunlit gold to build up the intensity of the flowers, diluting it with water to lighten the colours, and adding sunlit green in places. While wet, you may wish to drop in very dilute autumn gold where you see warmth.

- Before completing the flowers, add the dark background so you can decide how dark to paint them compared with your background. Use your tone checker (see page 44) when deciding on the depth of colour you wish to use.

- Use combinations of midnight green, country olive, ultramarine and shadow to paint around the composition as we did in the project, using the branches as natural wash breaks. Begin at the top left if you are right-handed, and the top right if you are left-handed.

- Drop in deeper colours in sections near to the flowers and use the wetted Golden Leaf brush to lightly stipple water into some of the background areas as you go along.

- Paint the background neatly up to the flower and leaf shapes using your Pointer brushes, making sure you keep each section wet enough so that it doesn't dry too quickly.

- Work all around the composition in the same way, finishing wherever you began, and leave this to dry completely before continuing. Adding a more varied background is a good way to improve and elevate a painting.

- Take your time to build up the colours on the leaves and branches, and to add the dark shadows to the flowers using a dilute ultramarine. Finally, add the centres of the flowers using autumn gold and shadow.

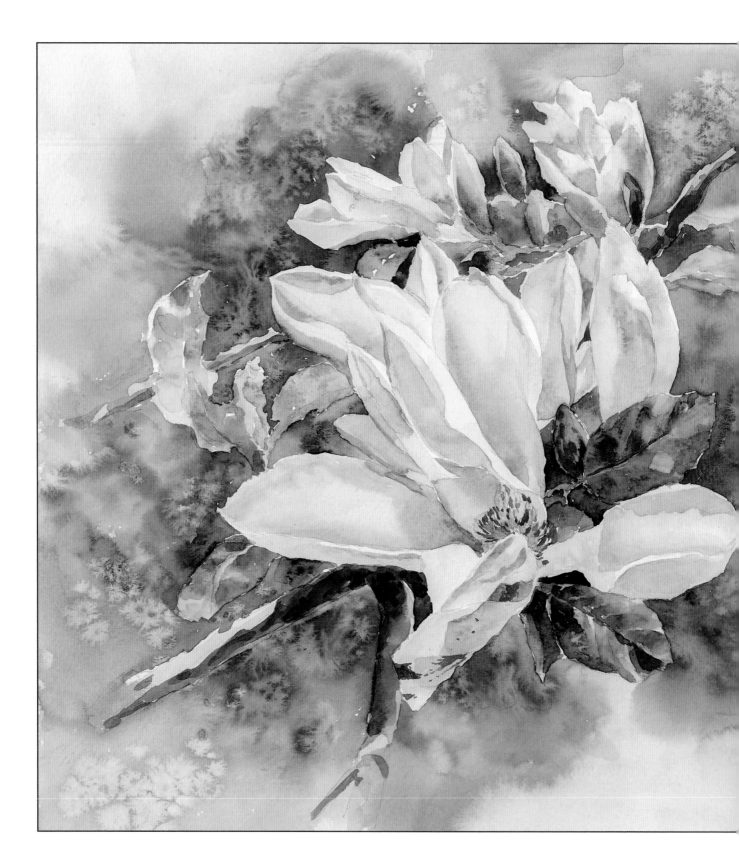

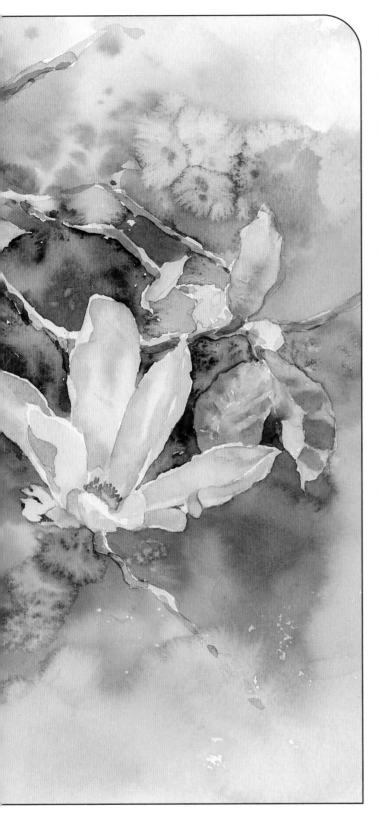

■ Adding more depth

Here I have added more leaves and buds to the composition to suggest more depth. The more textured background creates interest and gives the illusion of more foliage behind the magnolia. This is a simple technique I use for elevating interest in areas which may otherwise appear flat. Essentially, the subject is painted in focus, but gradually merges with a more abstract, out-of-focus background, leaving sections for the viewer to imagine.

To achieve this, I began by applying the palest colours on the petals and leaves, as well as establishing the positions of the branches. At this stage there were no shadows and no details.

Once this had dried, I painted the background, starting towards the edge of the paper with the darker section in between the flowers. This established my tonal values, and applying this dark colour took a bit of courage! Once I began to sprinkle a little salt into the dark wash, however, some of the pigment was absorbed into the salt crystals, lightening the tone of the background. Trust the process!

There was no need to complete the entire background in one go. As with the *Magnolia* project, I used the branches as natural edges for my washes and completed each of the sections independently, minimizing the risks of painting a larger area.

Once the entire background was complete and allowed to dry, I built up the rest of the painting in the same way as the project.

Magnolia 'Elizabeth'
55 x 36cm (21¾ x 14in)

This beautiful flower is named after the late Queen Elizabeth II. The outline is also available to download free from the Bookmarked Hub: www.bookmarkedhub.com, as described on page 54.

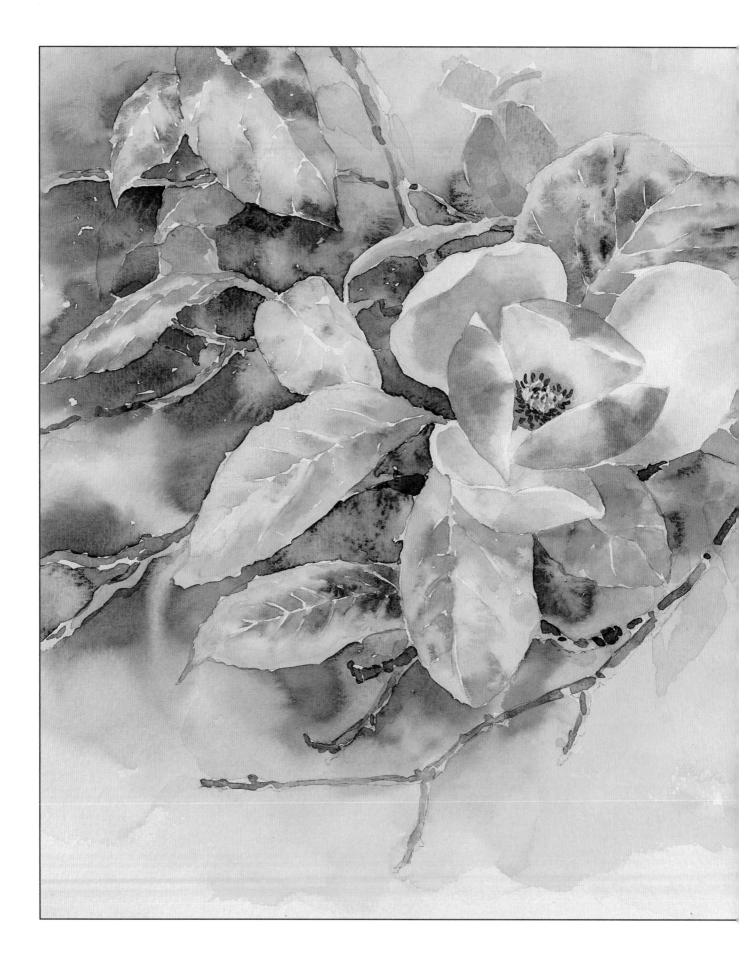

Finding your own way

We all have our preferred ways of working. Some artists enjoy the security of an indoor setting and a fixed place to work, using photographs and fresh flowers in a controlled environment, and – if they are lucky enough to be able to leave their work out – dipping into their chosen project over a period of time.

Others prefer the freedom of having a less structured approach to their subjects. Sketching and painting outdoors, where the light is constantly changing, and the weather could turn at any point, prove an exciting part of the painting experience for these artists, making them work faster and more intuitively.

Experiencing a variety of working environments is necessary to develop the way we evolve and increase our abilities. This part of the book explores different possibilities, so you can find you own preferred way of painting.

Magnolia 'Pickards Sundew'

52 x 34cm (20½ x 13½in)

The open flower and leaves appear to reach towards us. This impression was emphasized by painting a simple dark background, which was enhanced while still wet using the Golden Leaf brush to create textures, as explained on page 71.

The colours used for this painting were wild rose, shadow, ultramarine, sunlit green and country olive – it only uses techniques covered earlier in the book, so why not give it a go yourself?

Working outside

There is nothing quite like painting outdoors. If you decide to work outdoors, take the minimum of equipment with you, work on a small scale and aim to complete your painting in one session, preferably limiting yourself to an hour the first time you go out.

Working directly onto Yupo synthetic paper, as with *Spring Tulips* below, can be an uncomplicated way to begin, as any changes can be immediately altered. A simple pencil line drawing, similar to the outlines provided for the paintings opposite, would be ideal to work from.

Painting outdoors

Using any combination of colours you wish, take your painting kit outside and follow the painting process below – ideally on flowers from your own garden or perhaps a nearby park.

If you're unable to find any flowers nearby, I have provided outlines for the *Spring Tulips* painting and the two floral landscapes opposite, so you can experience the pleasures of outdoor painting anyway. I encourage you to adapt the scenes using the inspiration in front of you – perhaps substituting the colours of the foliage with greenery you can see first-hand.

- Either make a light drawing from what's in front of you, or transfer one of the outlines onto your watercolour paper, or place the outline under your Yupo paper.

- Using the Pointer brush, begin painting the flower heads. If you are painting the tulips, use wild rose darkened with a touch of shadow.

- Add the stems and leaves next. I used sunlit green, merging with turquoise for the tulips painting, and added the terracotta pots using the colour autumn gold, again merging this with turquoise. Paint a line under the pots to form the shelf.

- Once this has dried, use the colour shadow to paint the background squares suggesting the windows, diluting for the top windows and window frame.

Tip

If you like the idea of working outdoors but feel nervous, start by bringing the outside in. Take photographs and make notes outdoors, but do your painting back at your indoors work area. The important thing is that you have seen your own subject first-hand.

Spring Tulips　　Outline 15

9 x 13cm (3½ x 5in)

This is a perfect example of the sort of subject to tackle outdoors: small and compact. The simple shapes of the tulips are enhanced by the window behind them, which forms a lovely dark backdrop.

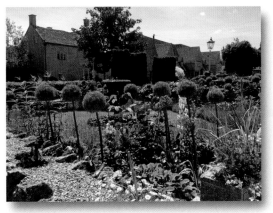

This simple, compact view of alliums in a garden can be simplified into a series of interlocking shapes easy to complete outdoors, making this a joy to paint.

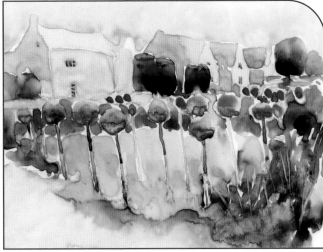

Alliums

Outline 16

20 x 16cm (8 x 6½in)

Avoiding all details, but instead looking for simple shapes, begin with the alliums to establish the scale. Next, position the dark trees behind them and slot the buildings in between. Afterwards, add the path, lawn and grasses on the right; then finally the sky.

Tip

It is easier to paint around a shape than to leave a space for it.

This photograph may seem complicated, but by looking at the subject with half-closed eyes, the main details become more obvious. This helps us to eliminate all unnecessary details.

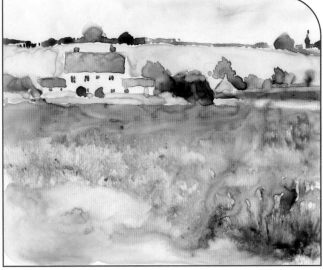

Cotswolds Lavender

Outline 17

15 x 19cm (6 x 7½in)

Begin with the oblong roof shapes, then work along the line of trees to establish the composition. Next, paint the distant trees and hedgerow positioned just above the chimney pots. While this is still wet, the lavender is painted as a single mass then the foreground green and lastly the sky.

Tip

Avoid all the small foliage details, and instead paint only the main subject.

Contour drawing

Contour drawing involves drawing the outlines of shapes, interlocking them together to form a logical whole. This requires us not only to look at the positive shapes of objects, but the space they occupy, often referred to as the negative space, or background.

Instead of thinking in terms of foreground and background, think of this type of drawing as fitting together shapes as you would a jigsaw puzzle. Observation is such an important skill: spending a couple of minutes looking at your subject before beginning is time well spent.

I use a propelling pencil for a consistent line – it won't blunten or need sharpening as you work.

At first glance this photograph might seem incredibly complicated – but as you don't have to use the whole photograph, you can select a section of it and focus on a smaller area.

1 Spend some time looking at the source photograph before you begin making any marks. Look at the dark shapes against the light ground, particularly the spaces and distances between the leaves and the stalks of the leaves. Take some time to really take in the shapes in front of you – very few are what you might expect of a leaf. Draw what's in front of you, rather than what you think should be there.

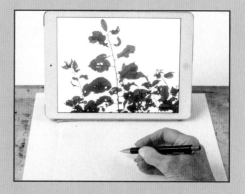

Tip

You can work from a printed photograph or directly from a tablet or computer, if you prefer. Being able to adjust the contrast on a screen can make things easier.

2 Using a propelling pencil, and starting from the top of the image, begin to draw in the image by outlining the shapes – both the dark positive shapes and the white negative shapes you observed.

3 Build up the drawing with constant reference to the source photograph. Try to avoid lifting the pencil too much – aim for a single continuous line unless absolutely necessary. The holes in the leaves here are a good example of when lifting off is necessary – but try to outline overlapping leaves, stems and other parts all as one continuous whole.

4 Gradually work down the drawing, moving slowly and carefully. Ideally, you will find that you become so absorbed with the detail of the line that you find you lose sight of the overall picture. This can lead to the drawing 'wandering off' to one side, giving a fresh and lively result, rather than a contrived and traditional 'pretty' picture.

Adding paint to your contour drawing

Once we have a contour drawing, we can use this as the basis to create our painting by transferring the lines onto watercolour paper or placing synthetic paper on top of our drawing.

Use this project as an experimental colour mixing exercise, dropping in any combination of colours you chose. You may find some of the results surprising and very useful in the future.

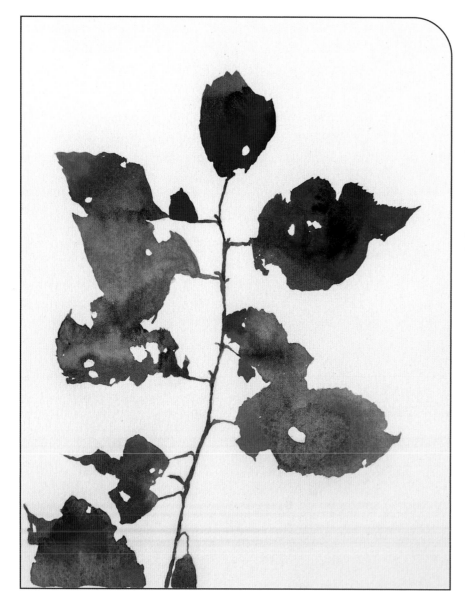

Contour study 1
22 x 28cm (8½ x 11in)

For this study, worked on 300gsm (140lb) smooth watercolour paper, I began with the top leaf, using a size 10 brush for painting the bigger areas. I swapped to a Pointer brush to drop in colours while it was still wet.

The Pointer brush is ideal for painting the thin stalks and any smaller areas. Leaves that overlap and appear as one shape need to be tackled in one go and kept wet while you drop in different colours.

Any combination of colours works well and will result in some wonderful effects.

Contour study 2

32 x 40cm (12½ x 16in)

Although this is a much bigger project than the previous one, it was tackled in the same way, the only difference being the addition of a pale colour to the whole background as if the leaves are painted against the sky.

Using the Golden Leaf brush, this pale blue wash of colour was added at the very start of the painting, and only when it was dry were the leaves painted on the top of it using the size 10 round brush and Pointer brush.

Unusual viewpoints

Before beginning to tackle any subject, consider viewing it from different perspectives.
An otherwise ordinary composition may be transformed by changing the viewpoint.

Contour drawings are an effective way of exploring different viewpoints without
investing time painting, another good reason to have a sketchbook or paper at the ready.

**Contour drawing of ripening pears on
the windowsill**

*Items placed on a windowsill viewed at an angle
can be a fascinating drawing subject. Much can be
learned by comparing one shape with the adjoining
one, looking at the patterns these shapes create.*

A different point of view

*For this contour drawing, I placed the three pears into the white dish and
moved them next to my coffee pot, then added the jug of daffodils. Standing on
a kitchen chair changed the composition to appear almost abstract. Place items
on the floor for a similar challenge.*

Tip

*Dropping imaginary plumblines
through your composition will help you
to see whether you have positioned
objects correctly.*

Daffodil with Coffee and Pears

21 x 18cm (8¼ x 7in)

The stainless steel coffee pot reflects the dark kitchen work surface. To avoid making the composition too dark overall, I placed a white napkin in the foreground to act as a stark contrast.

I began by painting the flowers and leaves, then added the coffee pot and pears. I started painting the dark background on the left side but once the dark was behind the flowers, I decided to leave a light section on the right to balance the painting. Notice that there is no line to indicate this in my contour drawing opposite.

If you feel the need to change something, alter it when you see it. Your instinct will probably be right.

Contour drawing: Daffodils with cottage

This contour drawing was made while outside, looking upwards at a bank of daffodils. I didn't notice the rooftops behind to begin with, as they were only just visible, and I was so busy concentrating on the daffodils and the patterns formed by the stems and narrow leaves. It was only as I reached the topmost flowers that I realized how lovely the addition of the roof line would be.

Project idea

Drawing outside can be extremely rewarding, and it is surprising what it can lead to. Take a sketchbook and propelling pencil with you the next time you go out for a walk. When you see a subject that interests you, make time to look for the less obvious composition. Once you have finished your drawing, take a moment to think about any colour notes or areas of strong contrasts which you may find useful if you were using it to make a painting.

Contour drawing using a propelling pencil.

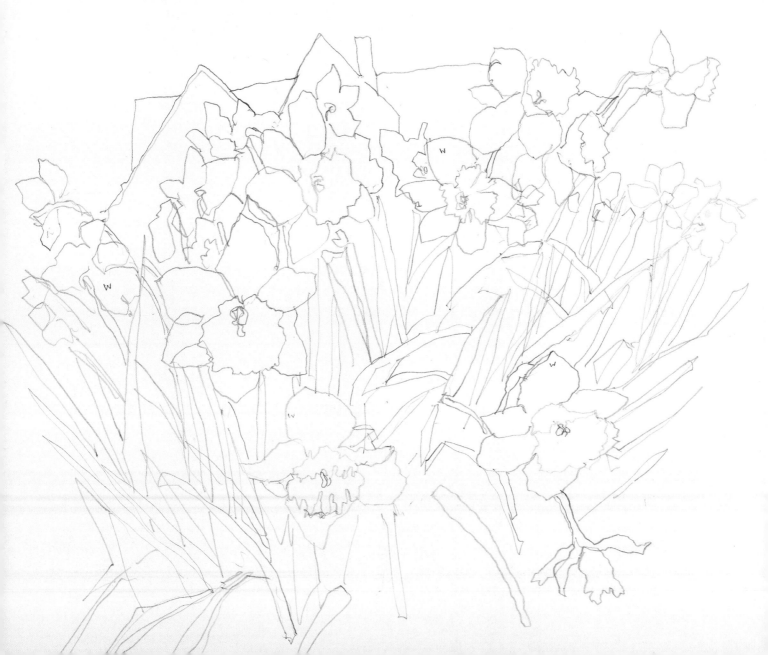

A Bank of Golden Daffodils

19 x 21cm (7½ x 8¼in) on Yupo paper

If you look closely at my drawing opposite, you may notice a tiny letter 'w' on four of the flowers. This was my quick shorthand to remind me that not all the daffodils were yellow, these were white, and I particularly liked the mixed colours and the fact that they were not all the same.

Although the drawing was complex, and more detailed than I would need to use for a painting, it is perfect to slide under Yupo paper and use it as a guide.

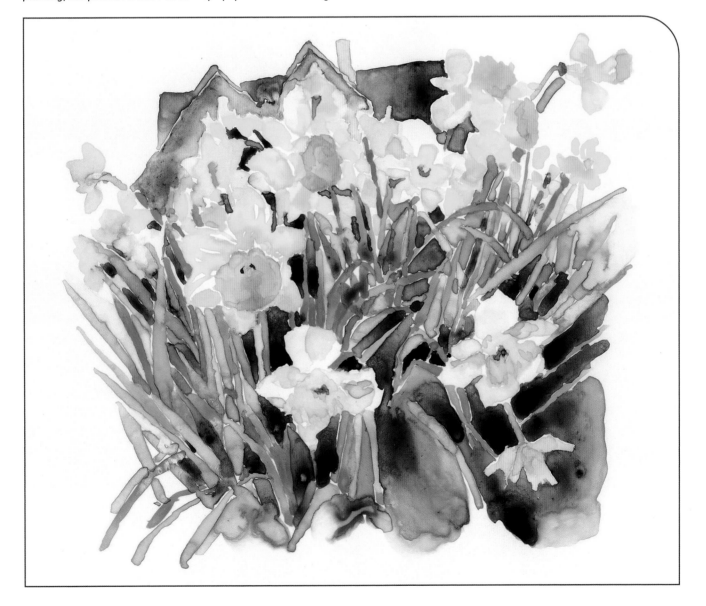

Saving white paper using masking fluid

Masking fluid is a liquid latex that is applied to watercolour paper and allowed to dry. It acts as a waterproof barrier that protects our paper so that we can paint over it. Masking fluid is easily removed once the painting is dry, revealing the clean unpainted paper surface. This can then be painted over or left white.

Although large areas of a painting can be protected using masking fluid, it is particularly useful for reserving fine details or small complicated sections of light or bright colours against darks.

Masking fluid can be used on synthetic paper in the same way, although care should be taken not to rub any nearby watercolour sections when removing the masking fluid. As the paint dries on the surface of synthetic paper (rather than being absorbed), it can easily be damaged.

Applying masking fluid with a ruling pen

1 Adjust the wheel to open the pincers until the width of the gap is ideal for your task.

2 Dip the tip of the pen into the masking fluid to load it.

3 Holding it just like a normal pen, with the side of the tip against the paper, pull the ruling pen backwards to apply the liquid.

Applying masking fluid with a brush

Masking fluid can be applied using a synthetic brush as these can be cleaned more readily than a natural-hair brush. This is better suited than a ruling pen for larger areas, like petals.

Before loading the brush with masking fluid, gently draw the hairs over a bar of soap. This helps to avoid the masking fluid clogging the brush, and makes cleaning it easier.

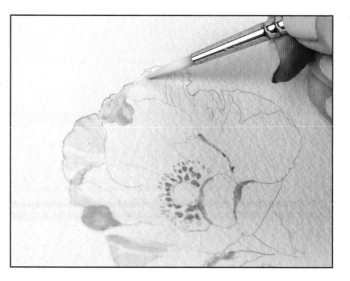

Painting over masking fluid

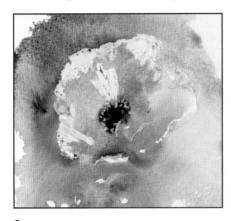 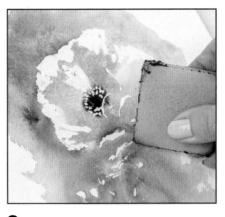 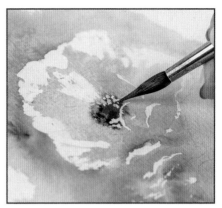

1 Cover the dry masking fluid with dark colour. Leave to dry.

2 Remove the masking by gently rubbing it away with an eraser or clean finger.

3 The revealed paper will be clean and white. If necessary to your painting, you can paint over these sections with a pale colour.

Tip
You can use a hairdryer to help speed paint drying times, but don't use the high heat setting if you're using masking fluid.

Rudbeckia

37 x 54cm (15 x 22in)

Using masking fluid on this painting allowed for a free use of colour without the need to avoid small fiddly sections.

The flower centres were masked out using a synthetic brush so that the sunlit gold and midnight green could be freely painted over the top.

The grasses were masked out using a ruling pen and, once dry, any masked lines which covered foreground leaves were rubbed off before painting.

Tip
A ruling pen can be used to apply watercolour paint in the same way as masking fluid.

Camellias

Camellias have such deep, luscious colours. The firm, stiff leaves have a shine on them while the veins are beautiful bright green, paler than the leaves themselves. We will reserve the light with masking fluid, and overlay the colours afterwards. This allows us to drop in the darks without having to worry about avoiding the veins.

The flowers have firm petals with tiny veins, but as we can only see these when we look closely, there is no need to paint these details unless you wish to. The flower centres are particularly dark – the stamens are almost the same tonal value as the petals – but the seed heads add sufficient detail to ensure the centres of the flowers all make sense visually.

Source photograph

Outline 18

You will need:

Paper: 38 x 28cm (15 x 11in) Bockingford Not surface 300gsm (140lb) watercolour paper

Brushes: two size 10 rounds, Pointer brush

Paints: Autumn gold, wild rose, shadow, midnight green, ultramarine, country olive

5B pencil and putty eraser

Masking fluid, ruling pen and masking fluid eraser

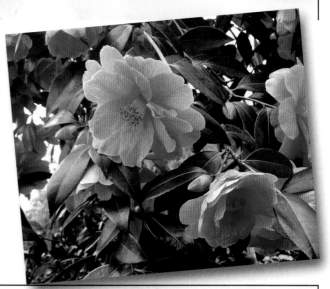

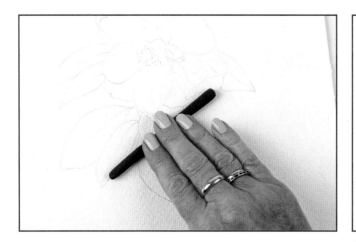

1 Transfer the outline as described on page 17 and ensure the lines are not too dark. If you need to soften them, shape the putty eraser into a sausage, then gently roll it over the surface. It's important to do this before applying the masking fluid, as the fluid will protect the pencil lines as well as the clean paper.

2 Use the ruling pen on a fine setting to apply the masking fluid: it is extremely accurate, and your narrow line will be the same from start to finish. Draw the veins on all the leaves and the light on the edges of the petals. If the line is not what you want, remove it and have another go. Leave to dry.

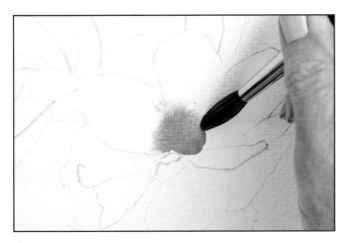

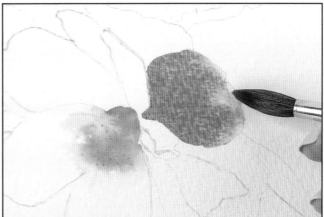

3 Prepare a small amount of autumn gold with just a touch of white gouache, and use the resulting peachy mix to paint the flower centre, applying the paint with the size 10. Draw it out with a damp size 10 to create a soft edge.

4 The petals are lighter at the edges than the centre, so we need to start in the centre and encourage the pigment to diffuse outwards. On the dry paper, apply strong wild rose to the base of a petal, then use a second size 10 brush to cover the remainder with clean water before bringing the paint into the water.

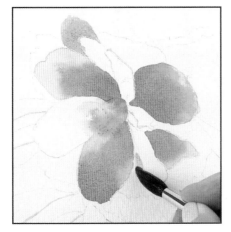

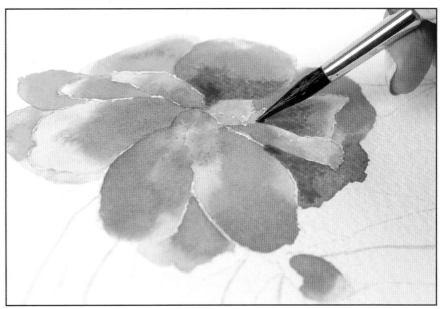

5 Still using the size 10 brushes, work on alternate petals to avoid paint running from one to another.

6 Allow to dry, then paint the remaining petals and the bud, leaving space for the green later. Once the painting is completely dry, add a touch of shadow to a pool of wild rose and add touches of this darker mix to strengthen areas of deep tone within the flowers. You can still use the size 10 round brushes, but for really deep tones, use the Pointer to drop in additional dilute shadow while the paint is wet.

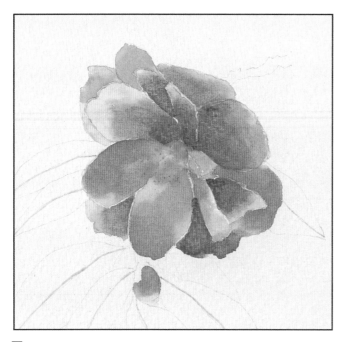

7 Don't overdo the shadow by applying it to every petal, or you'll lose the contrast that you're building. Apply more to the petals on the right-hand side, as these are the ones out of direct sunlight.

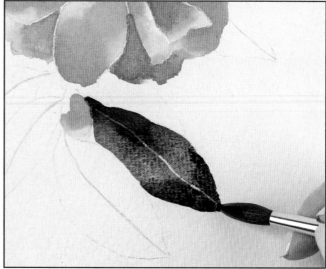

8 Once the flowers are complete, turn to the leaves. Create pools of strong midnight green and strong ultramarine and use them in combination to start to paint the parts of the leaves in deepest shadow. Use two size 10 round brushes, one for each colour, and apply the colours one after another, letting them interact on the surface while wet. Work right over the masking fluid.

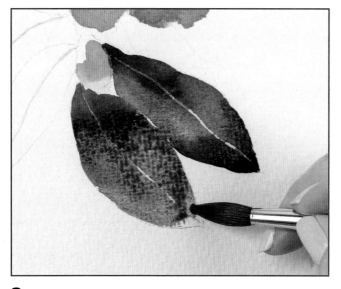

9 Vary the colour by introducing a little country olive. This is really useful to help nearby leaves 'read out' from one another.

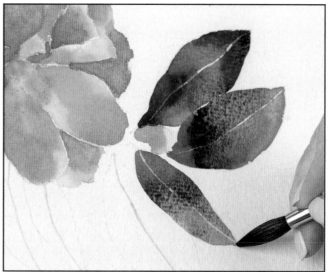

10 Work round the other leaves. Feel free to turn the paper – it will help you to avoid accidentally getting your hand in wet paint, and make your brushstrokes more natural and less awkward.

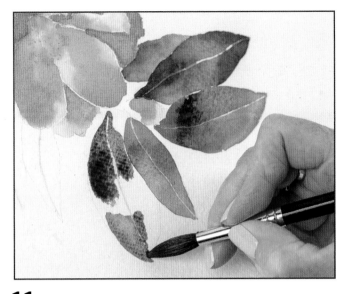

11 As you work round, use more water to brighten the tone. Apply the paint at the tip and base, then use water to link the two, creating a light-toned highlight area.

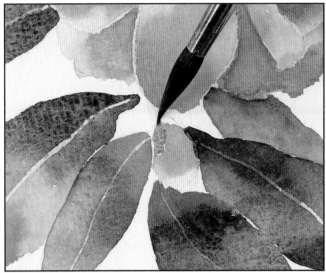

12 With all the leaves in place, use the Pointer brush to paint the green on the bud.

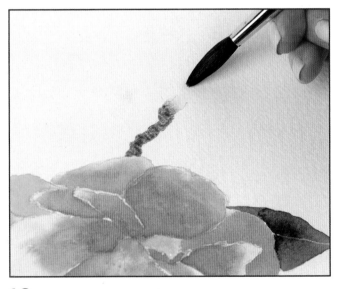

13 Use wild rose with a touch of sunlit green to create an attractive brown mix, and use this to paint the stems. Apply the paint with the size 10 round brush, and use a clean damp brush to soften the end away into the background.

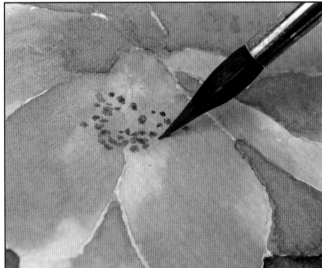

14 Using the same mix, apply the details to the centre to the flower with a Pointer brush.

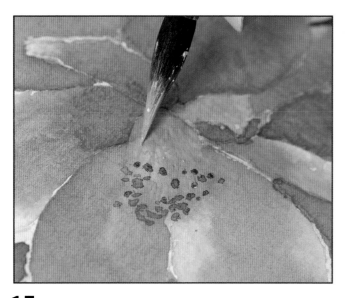

15 Add gouache to the mix to add some linear marks.

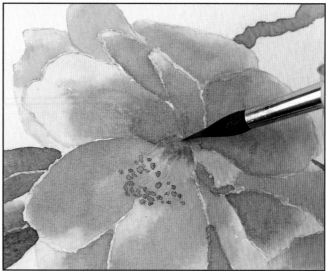

16 Using a mix of wild rose with a touch of shadow, darken the very centre of the flower to help give these marks a firm base.

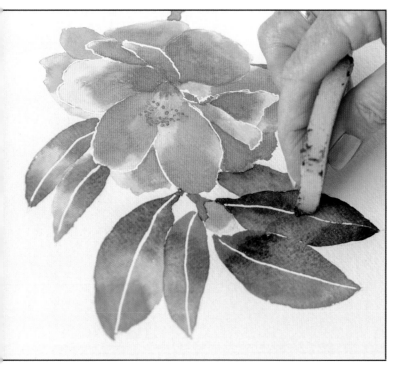

17 Once completely dry, remove the masking fluid by gently rubbing it away.

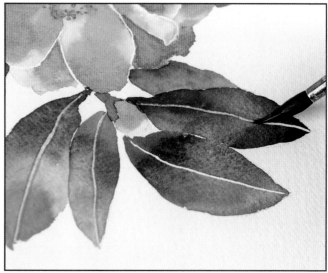

18 If you feel the revealed white is too stark a contrast, use the Pointer to apply very dilute paint over the top; wild rose on the petals, and country olive on the leaf veins. Keep the paint very, very thin, and don't cover all the white marks on the petals – the additional contrast will help the flower appear sunlit.

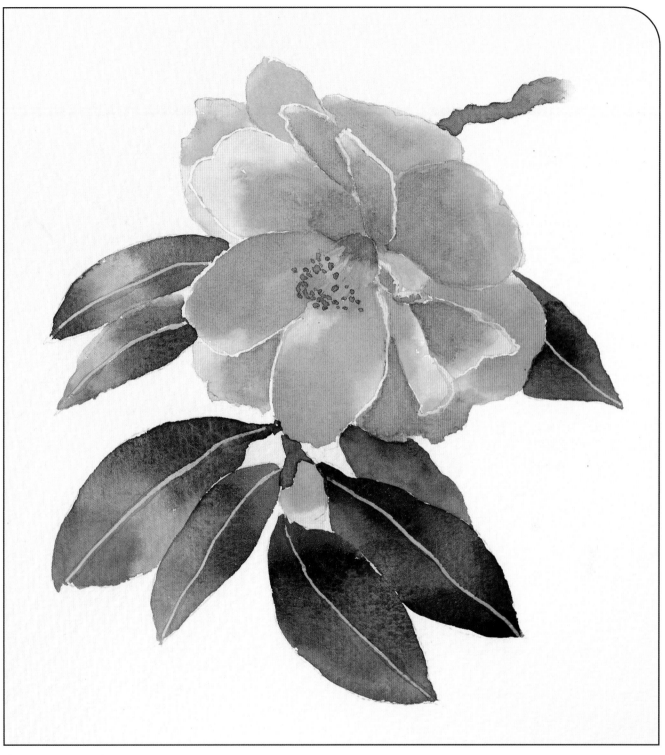

The finished painting

Going further

This painting builds on the skills you have practised in the project on the previous pages – use the colours and techniques there together with the notes below.

For this composition, I tilted the source photograph on page 96 to the left, so the positions of the flowers created a flow across the page. I simplified the composition by moving the foreground bud and leaf cluster upwards, pushing it towards and between the two open flowers. The beauty of using a photograph in this way is that you can alter your composition depending on the shape of your paper.

- Transfer the image onto your watercolour paper and use the ruling pen to apply masking fluid to the leaf veins and the tiny sections of light separating some of the petals. Avoid outlining the petals – look carefully at the reference photograph to see where the light catches the petal edges.

- Use the size 10 round brush and begin with the large flower, exactly as in the project, dropping in darker colours using the Pointer brush. Add the tiny buds and spray of leaves in the same way, then finish the flower as in the project.

- Begin the second flower in exactly the same way, adding more of the shadow colour to the inner section of the flower. This will help to suggest the round form of the open bloom.

- Add the adjoining leaves and attach them to the stem while they are still wet. This will give the appearance that they are growing from the stem rather than attached to it. Drop in very dilute ultramarine to suggest the light on the leaves.

- Paint the flower centre using the darker mix, adding shadow if it needs to be further darkened; then add the leaves and stem at the top of the composition.

- Leave the painting to dry thoroughly before adjusting any of the dark areas. Any section that requires darkening needs to be done before the masking fluid is removed, so think carefully about the depth of colour you have achieved particularly in the centre of the flowers and use your tone squares to check the depth of tone.

- Once you are satisfied and the painting is thoroughly dried, gently remove the masking fluid.

- Using the Pointer brush, add a very dilute wash of wild rose where the masking fluid has been removed from the flowers, and use a dilute country olive or sunlit green for the central leaf veins.

- If you feel that your colours are all paler than you had wished, you can add a dark background similar to that in the previous project; this will provide a tonal contrast and enhance your painting. If the leaves appear dull and flat, you can use a dilute wash of yellow gold in areas to brighten them.

Vibrant Camellias
37 x 33cm (14½ x 13in)

The outline is also available to download free from the Bookmarked Hub: www.bookmarkedhub.com, as described on page 16.

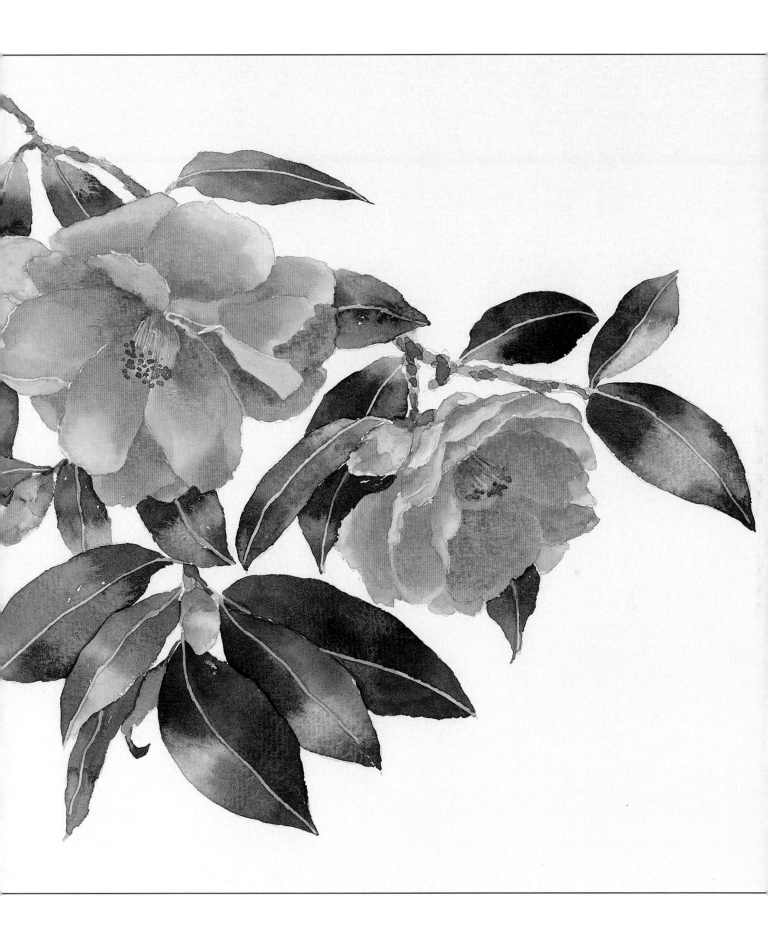

Adding a soft background

For this painting, I used the same six colours as in the project. As with *Camellias* on pages 96–101, I chose to turn the composition more on the diagonal so that the flowers made a more pleasing flow across the paper. I moved the leaves and arranged the clusters to exaggerate the direction of growth. I filled in the gaps with lots of leaves, and added the tiny veins on the flowers using a stick dipped in paint, before adding a soft background – which I think can really elevate a painting.

After drawing leaves in the foreground like this, there will almost certainly be gaps that need filling. There are various ways to approach this – you could add more leaves using the same shapes and leaf directions as the foreground leaves, or, if the gaps are small, they can be filled with dark greens, suggesting sections of leaves in the background.

We know by looking at the photograph that there are more branches and leaves at the top and behind our subject, but we do not need to include everything we see. I added just one additional branch at the top of the painting, and kept this section clear of leaves. I also kept the colours slightly paler at the top of the painting to give the impression that the branches appear to be in the background. This draws the attention of the viewer down and diagonally across the painting.

The techniques for painting the flowers and the colours used are exactly the same as those used for the project and *Vibrant Camellias*. For this more developed painting, I added the tiny veins on the flower petals using a stick dipped in a strong mix of wild rose (see page 112 for the technique). This enhances the direction in which the petals grow, and the added detail increases the complexity of the painting. Why not give it a go yourself?

When adding a soft wet-into-wet background to a painting, always use a colour or colours previously used in your composition to keep the painting unified.

Camellia Japonica
45 x 36cm (17¾ x 14in)

The outline is also available to download free from the Bookmarked Hub: www.bookmarkedhub.com, as described on page 16.

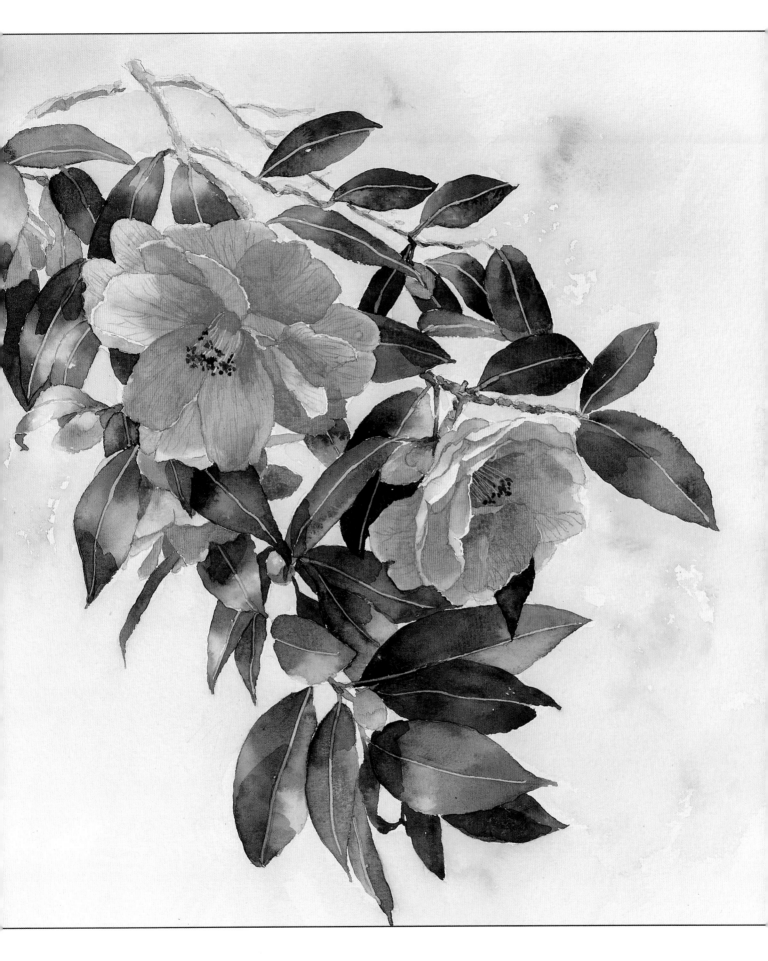

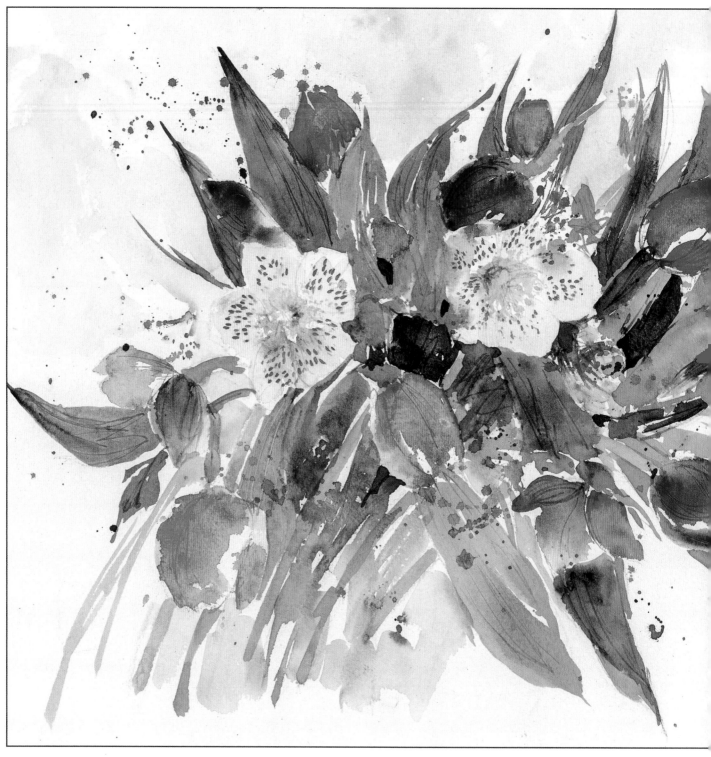

Spring Posy

50 x 36cm (20 x 14¼in)

These tulips and hellebores were in a large glass vase which I turned to try out different viewpoints. I began with the hellebores and positioned the tulips and leaves around them, then extended the composition diagonally in both directions using various parts of the arrangement. The result is a freedom of movement across the page which did not, in reality, exist.

Creating movement

Think of movement as 'liveliness' or 'expression' rather than implying that our composition is literally moving. This can be achieved in many ways. Positioning our subject on the paper to suggest direction, coupled with a looser approach, is a great way to start. Splashing and flicking the paint can also suggest speed and immediacy – it doesn't necessarily mean you're a messy painter!

The confidence to paint more freely and loosely takes time to develop, so it is important to have all the basics in hand. Get comfortable with colour mixing, with paint consistency, with how the brush feels depending on how much liquid it's holding, and with how much water is needed to move paint on the paper.

An effective way to begin adding more movement to your work is by working with more liquid, and making sure your brush is well loaded. In this part of the book, we will also try moving the paint with a palette knife or stick; tilting our board; and for a textured result, using a spritzer. Once these skills are practised, the addition of pigment inks can be very exciting.

Let's begin by inviting our colours to flow and move.

Loosening up

Adapting to what happens when colours run and 'going with the flow' will improve your understanding of watercolour and encourage you to paint with more freedom.

'Go with the flow'

Loose studies can be perfect for more experimental works. Painting the same subject a number of times helps to develop ideas, build confidence, and give you a better understanding of how to react to situations as they occur.

The aim of this exercise is to go beyond the lines. Outline 19 provides you with the key area of tulips as a starting point, but we're going to paint additional tulips and stems freehand.

Transfer outline 19 to your watercolour paper, and be prepared to react depending on the results that emerge as you work. You can change your mind if necessary!

The colours used here were wild rose, shadow, cadium red, turquoise, ultramarine and country olive.

Freehand stems
Use long free strokes to paint the freehand stems, drawing them out from the flower heads. Don't worry about the exact direction; just aim to get a long, loose stroke.

More flower heads
To paint additional flower heads, load the brush heavily with paint and place it flat on the surface, before slowly drawing it downwards, letting the shape of the brush inform your marks.

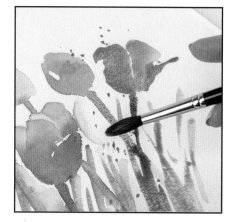

Spattering
Spattering is a technique that creates lovely free marks. Load your brush, hold it a little way above the paper, and tap the brush firmly just behind the ferrule. This will send some small spatters of paint onto the surface.

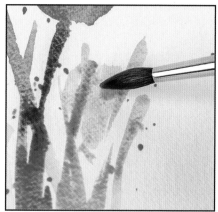

Background flowers
Try adding extra background flower heads freehand, using the stems to help guide you. Use more dilute, paler mixes to help sit them in the background.

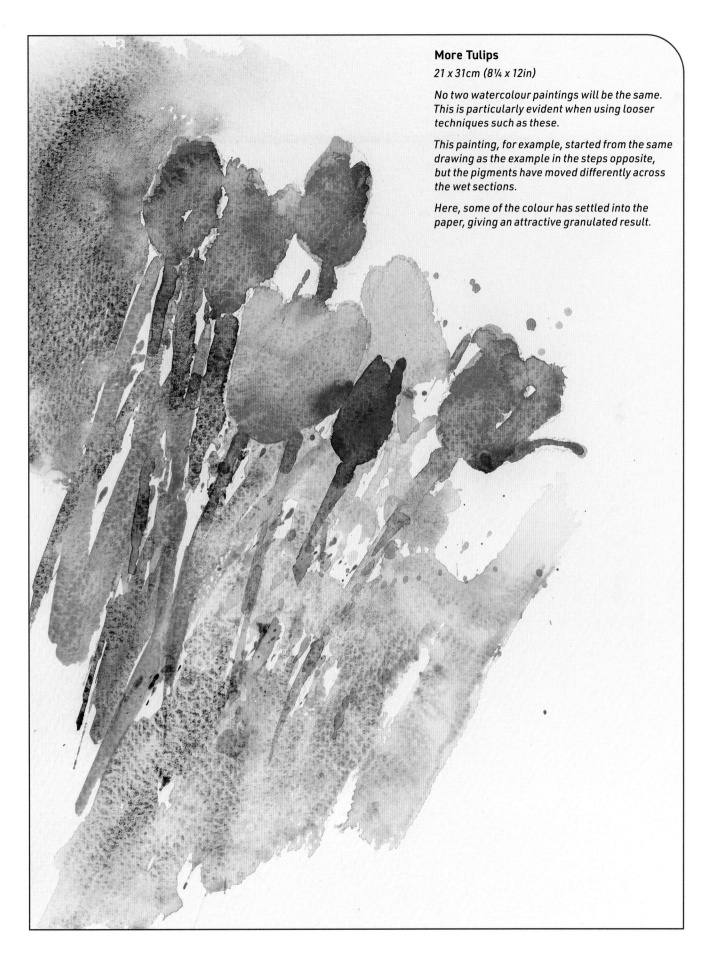

More Tulips

21 x 31cm (8¼ x 12in)

No two watercolour paintings will be the same. This is particularly evident when using looser techniques such as these.

This painting, for example, started from the same drawing as the example in the steps opposite, but the pigments have moved differently across the wet sections.

Here, some of the colour has settled into the paper, giving an attractive granulated result.

Moving paint with a palette knife

Palette knives can be used to move wet watercolour, with a little practice. As you move the knife, the wet paint will be parted, leaving a light, almost dry section of paper which will function as a barrier if more paint is dropped into wet paint adjoining it. You can create texture by moving short sections of the wet paint (see the tree bark on page 51, for an example). You can suggest stems and leaf veins (such as those on the leaves of the iris on page 113) by moving longer sections.

You need a palette knife with a rounded end, and to apply just enough pressure to move the paint, without scoring or damaging the watercolour paper. Heavier papers are more tolerant – thin paper is easily damaged.

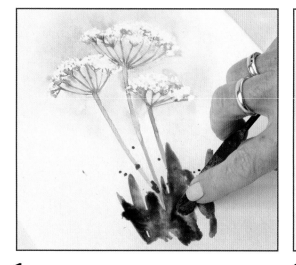

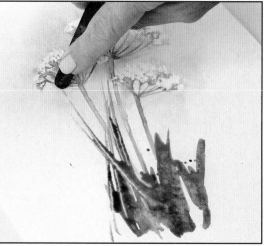

1 Working in wet – but not pooling – paint, place the tip of the palette knife down on the surface where you want your mark to start. Use light pressure. If you work too firmly, you'll indent or damage the paper, and the fluid paint will flow back into the gap you make.

2 Draw the paint out in a single swift movement. This will leave a pale gap in the wet paint and draw out a fine line that is perfect for grasses. To taper the mark off, lift the palette knife away as you make the stroke: reducing the pressure will result in a finer line.

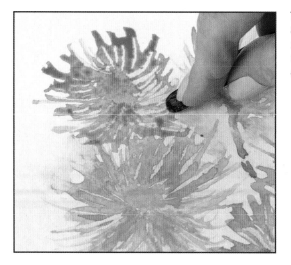

This technique is great for the petals of flowers like these asters. Keep the marks shorter, purposely stopping the stroke. Use a constant pressure to create lines of consistently even width.

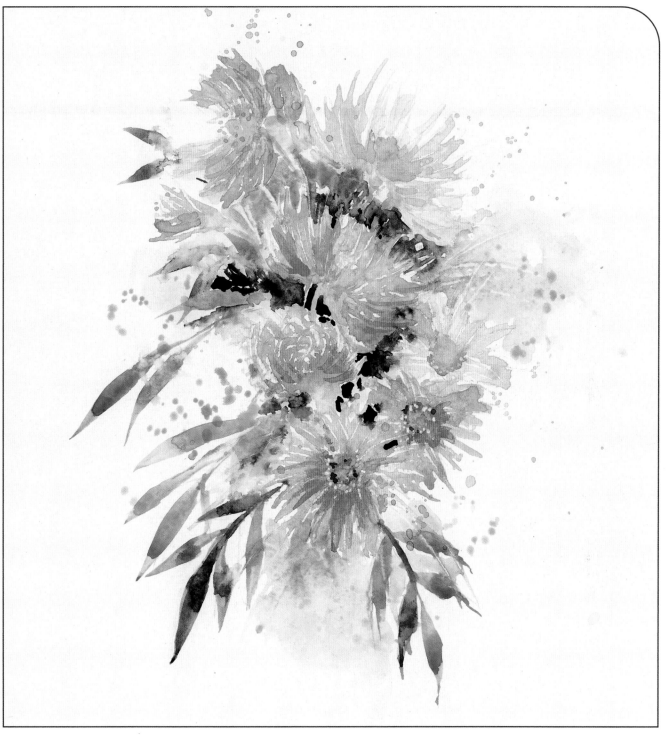

Asters

22 x 29cm (8¾ x 11½in)

Asters come in an amazing range of colours, so any combination works! Add some leaves and some background colour, flick some splashes onto the painting and include some details in the centre of the flowers to improve your study. This is a wonderful way to experiment with techniques and develop your ideas into bigger pieces.

Using a sharpened stick

A sharpened stick is the perfect tool for moving wet paint in a dynamic, linear way to suggest directional movement. The stick can be either dipped in a well of colour, rolled on a wet palette, or the paint can be applied directly to the stick using a brush.

I choose to use foraged hardwood twigs found on my walks. They need to feel comfortable in my hand, so finding the right one is always a joy. I allow them to dry out if they are wet, then use a sharp knife to shape them into differing angled points.

This technique is very versatile. Ideal for curved lines such as grasses, as well as small stamens, and leaf veins; it is also great for hollyhocks. An example of this technique was even used on the background trees on page 51.

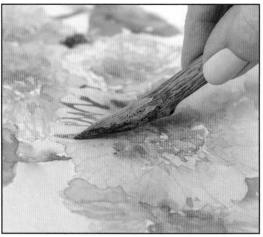

Holding the stick

Place the stick before you on the paper. Lay all four fingers on the top of the stick, then place your thumb underneath the stick.

Turn the stick so that you're holding it comfortably in your hand and it sits almost flat against the paper.

Applying the marks

Don't try to use the tip like a pen. Instead, create curved lines and rock the stick gently from side to side to suggest angled lines, both thick and thin.

Opposite:
Iris
32 x 46cm (13 x 18in)

The shape and delicacy of the iris petals is suggested by using a sharpened stick and drawing with wet paint in the direction of the petal shapes. The dark grasses were painted using this same technique.

The colours used were shadow, bluebell, autumn gold, turquoise, midnight green, country olive, sunlit green and sunlit gold.

112

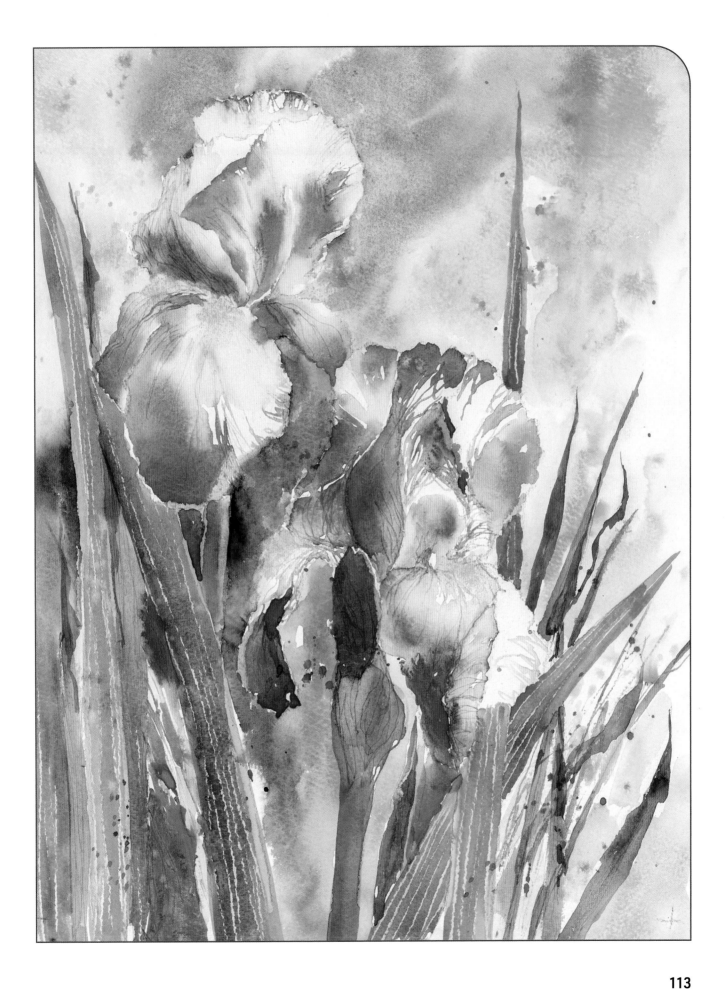

Floating pigment inks

One of the aspects of painting in watercolour I find more exciting and mesmerizing is watching it flow across wet paper as if it has a life of its own.

Pigment inks can be diluted with water and used in the same way as watercolour. However, when the ink is applied to the wet surface and not agitated, it separates and clumps together, forming little islands of pigment. To create these lovely effects, the ink must float on top of either water or dilute watercolour. This process must not be rushed as the ink takes a minute or so to separate. The surface should be as wet as possible.

You can add more than one ink at once, too, allowing for wet-in-wet mixing. The pigment inks used in this example were shadow and midnight green.

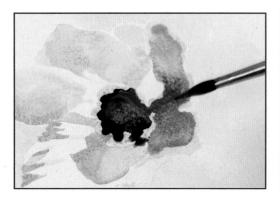

1 Working on top of very wet paint (or a pool of clean water), bring the tip of the ink dropper to your pool.

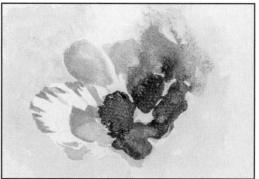

2 Add tiny touches of ink to the surface of the wet paint. Be careful not to push through the water's surface: it has to sit on top.

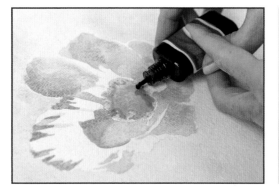

3 Wet an adjacent area with clean water, then use the tip of the Pointer brush to encourage the two wet areas to touch. The ink will rush across, diffusing out.

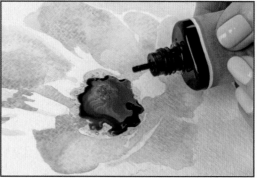

4 You can keep working as long as the paint remains wet enough to carry the pigments. Try not to touch the ink itself; instead invite it to diffuse on its own, by allowing it a path with clean water. Tilt the paper to encourage the colour to flow in the direction you want.

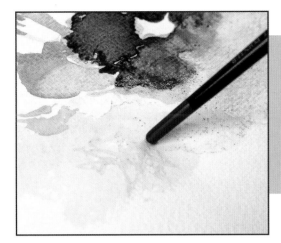

Tip

If you want to make more linear marks, use the back end of a brush to make scribbly marks with water, then tip the paper to encourage the ink to move into the area.

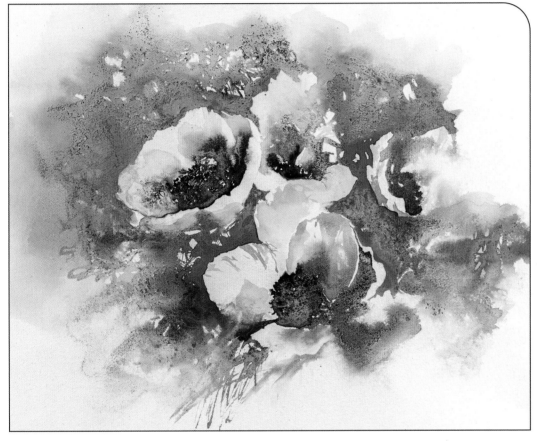

White Anemones

46 x 33cm (18 x 13in)

Here I have been heavy-handed with the ink, creating lovely dark tonal areas.

I used autumn gold watercolour as my base for the warmer areas. While wet, I dropped in shadow and midnight green pigment ink. Midnight blue ink was used in the background sections on top of a base colour of a very dilute midnight green watercolour.

Once the ink had settled onto the wet base, turquoise watercolour was flicked onto the damp surface. Turquoise is a little opaque, so providing it is undisturbed, it will remain on top of the ink.

Using a spritzer with pigment inks

A spritzer can be a useful way of adding water to the paper without touching the surface with a brush, so is ideal when using pigment inks, allowing the ink to disperse naturally. Tilting the paper may also help to encourage the colour to move in the desired direction.

1 Add the inks to a pool of water as described on page 114.

2 Create channels to help direct the flow of ink using a stick, drawing the liquid out from the pool. Draw the channels past the flower to ensure you don't cover it.

3 Use the spritzer to spray the area beyond the sunflower petals.

4 Tilt the paper to encourage the ink to flow down the channels and spread out into the spritzed area.

Tip
You can spray more to allow the ink to flow further.

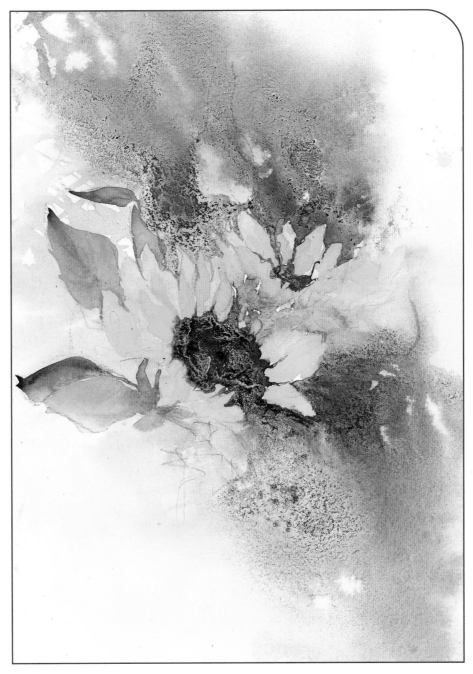

Sunflower study

27 x 40cm (10½ x 15in)

After loosely painting the sunflower shapes using sunlit gold and a touch of autumn gold, and adding a background of country olive, I allowed the painting to dry. I then painted an area in the centre of the main flower using autumn gold and immediately added a single drop of shadow pigment ink, followed by a drop of midnight green pigment ink.

Using turquoise and sunlit gold watercolour, I wetted the adjoining background section. I tilted and sprayed the background section to invite the ink to flow into this wet area, flooding it with texture and diluting the colours. I allowed the excess to run off the page onto some kitchen paper. Once this had dried, I used this same technique to paint the second flower, inviting the ink to flow towards the corner of the paper, spritzing to dilute and tilting the board in that direction. Once dry, I added a couple of leaves using country olive.

Blue Hydrangea

This blue hydrangea is such a striking colour. The centre is like a collection of jewels, surrounded by paler open flowers that contrast sharply with the large glossy leaves – making this flower the most wonderful subject to paint.

 The techniques we use here can be applied for any type of hydrangea, enabling you to use your own photographs in a similar way, and adapt them to different coloured flowers.

You will need:

Paper: 30.5 x 40.5cm (12 x 16in) Bockingford Not surface 300gsm (140lb) watercolour paper

Brushes: two size 10 rounds, two Pointers, Golden Leaf

Paints: Shadow, wild rose, ultramarine, country olive, turquoise

5B pencil and putty eraser

Masking fluid, brush, soap and masking fluid eraser

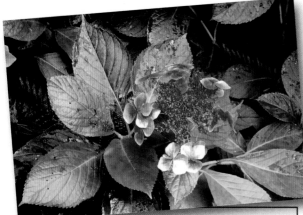

Source photograph

1 Transfer the image from outline 21 to the watercolour paper, then soften the lines with a putty eraser (see page 54). Use the brush to apply masking fluid to the areas shown.

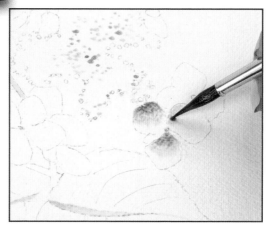

2 Prepare separate pools of shadow and wild rose. Use one of the Pointers to wet alternating petals of the flowers, then use the other Pointer to drop in small amounts of shadow and wild rose, allowing them to mix on the paper. Notice that the foreground petals are very pale, so be sparing when applying paint to these.

Tip

Of course, if the petals of a particular flower don't touch each other, there's no need to avoid alternate petals: just make sure the colours won't bleed from one to another.

118

3 Introduce ultramarine to the flowers that appear more blue. Once the first group of petals has dried, paint in the remainder with the same colours and techniques, still using the Pointer.

4 Swap to a size 10 round brush to paint a very dilute ultramarine on the leaves where the light is shining on them. Use larger, sweeping marks to start on the left-hand large leaf at the top left. While the paint is wet, introduce turquoise on the right-hand side in the same way, then add dilute country olive in the spaces and allow to dry. The masking fluid in the centre acts as a barrier, preventing the colours mixing too much and giving the impression that the two halves of the leaf are being hit by the light differently.

5 Still using country olive, drop in colour on the left-hand side to suggest the shape of the leaf. You don't need to follow the lines of the drawing exactly; just aim to suggest the direction of the smaller side veins. Because the right-hand side of the leaf is darker than the left, drop in a little ultramarine down the length of the central vein. This will merge with the existing colours and create some variation.

6 Paint the other leaves in the same way. Use more country olive on the leaves that appear less blue in the source photograph.

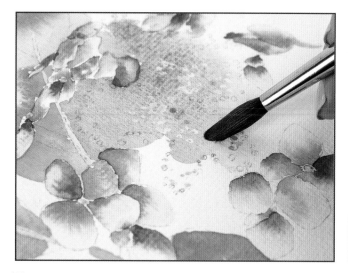

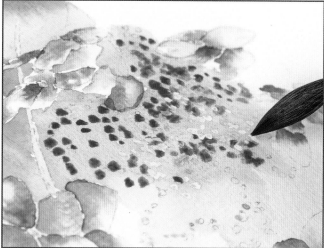

7 Extend dilute ultramarine from the leaf at the top right across the hydrangea centre. Soften the edges (see page 64) to create an indistinct feel.

8 Once completely dry, use slightly stronger ultramarine and turquoise to build up the texture on the hydrangea centre. Create small, overlapping dots with the tip of the brush. Don't cover up the background entirely – keep some of the lighter underlying colour showing through. Try to ignore the masking fluid – work straight over it to create as natural a finish as possible.

Tip

The centre of this flower is a perfect place for inks, if you'd like to experiment. Wet a blob in the centre, add a drop of midnight blue pigment ink, then spritz from directly overhead, keeping it in the centre of the flower.

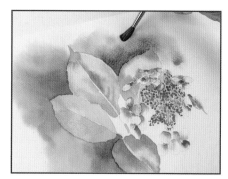

9 Prepare a well of paint for the background, with large amounts of ultramarine and country olive that are muddled together, but not overmixed, and a smaller amount of shadow.

10 Use the Golden Leaf brush to apply clean water to a section of the background, leaving a small gap by the image. Next, use a size 10 to add the ultramarine and country olive mix in the gap, encouraging the colour outwards.

11 Work around the whole background in a similar way, varying the amounts of ultramarine and country olive you use to create a variety of different tones, with the areas nearer the centre darker than those further out.

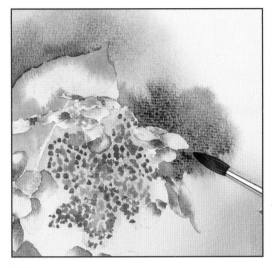

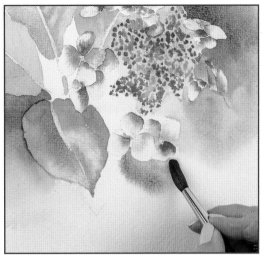

12 Avoid touching the flower itself when you come to that section. Use darker tones by picking up a touch of shadow alongside your other colours. Aim for a lovely crisp edge here, by using negative painting to suggest the shape of the flower centre.

13 As you work all the way round, you'll reach the point at which you began. Work over that in the same way, helping to create a natural blend rather than an obvious line.

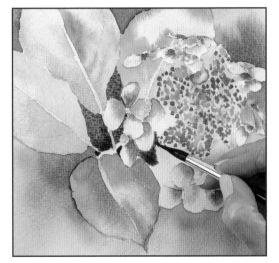

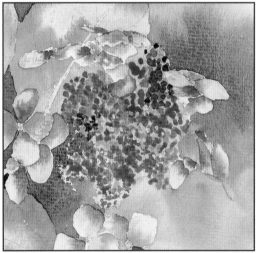

14 Once dry, use the Pointer to paint in the small enclosed areas at the centre with the same colours. Try to match the colour to the surrounding background (so use more blue if the nearby background is blue-tinged), but add a little more shadow to the paint you apply, as well.

15 Where the dark green background goes underneath the flower head, use a size 10 round brush to add small dots with a strong mix of ultramarine and country olive. This helps to blend the areas together and add depth to the flower head. Don't overdo it – this should be subtle – and keep the green dots well away from the centre of the flower head.

16 When the painting has completely dried, add more depth to the leaves. Use two brushes, a Pointer to apply small details on the dry surface, and a size 10 round to draw out the colour with clean water.

17 Vary the colours as you work across the leaves; matching or contrasting the underlying colours as you prefer. If you would like to make the distinction between leaves more clear, try darkening one or the other using very dilute ultramarine to push it back a little, visually.

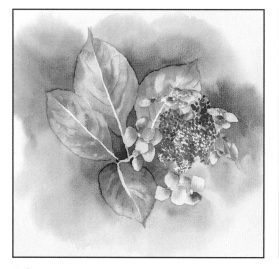

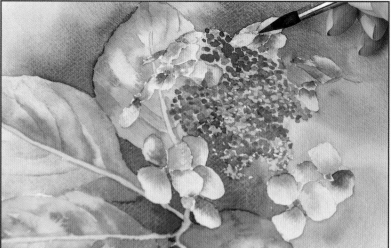

18 Once completely dry, remove the masking fluid with the eraser or a clean finger. To check you've removed it all, gently run your hand over the surface – any small bits you've missed will be very obvious under your fingertips.

19 Use the Pointer brush to paint the revealed veins with very dilute country olive. It's easier to start at the end of the leaf and work down towards you – ideally in one smooth movement to help avoid disturbing the paint. Where the leaf widens, apply a little more pressure to make a broader brushstroke. Use the same colour on the flower head, to give the impression you can see through the flower head to the foliage behind. Add the flower centres with tiny touches of wild rose to finish.

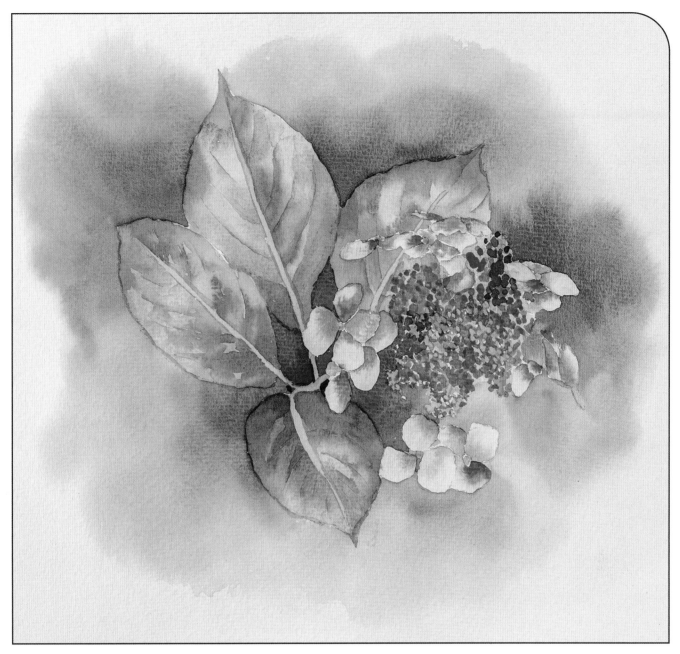

The finished painting
30.5 x 40.5cm (12 x 16in)

Going further

This composition has more leaves and some tiny buds than the preceding project, but the techniques and colours we use are the same. Our challenge here is to create more depth and a feeling of sunshine by using stronger tonal contrasts, as well as creating some lovely textural background effects using water.

- Begin by applying masking fluid to the leaf veins and tiny central flower buds. Once dry, paint the open flowers using the Pointer brush, as in the project.

- While the petals dry, use a size 10 round brush to paint the larger leaves that are not adjacent to any wet flowers. Paint the remaining leaves (except the one which has buds on it) and the centre of the flower as soon as the open flowers are dry.

- Using the Pointer brush and a stronger mix of ultramarine and wild rose, paint the dark buds in the centre of the flower as well as those on top of the leaf.

- Prior to adding any details on the leaves, establish the dark background in the very centre of the painting using two size 10 brushes; one for midnight green the other for country olive. Carefully paint the shapes in the centre, varying the colour slightly as you work.

- Decide which direction you're going to work around the rest of the background. If you are right-handed, start at the top left and vice versa if you're left-handed. Wet the first section of background with clean water using the Golden Leaf brush, then use the size 10 round brushes to paint the darkest colours next to a leaf edge and wash the colour towards the wet background.

- Continue in this way around the entire composition, occasionally swapping to the Golden Leaf brush to stipple water onto the wet dark sections (see page 71).

- Use the colours as dark as you dare: the water will both lighten the section and create lovely textures.

- Once the background is dry, paint the remaining leaf, avoiding the buds. Use the Pointer brush to add details to the flowers and leaves. Ensure that some of the leaves are so pale that they fade into the background.

Hydrangea in Sunshine

37 x 33cm (14½ x 13in)

The outline is also available to download free from the Bookmarked Hub: www.bookmarkedhub.com, as described on page 16.

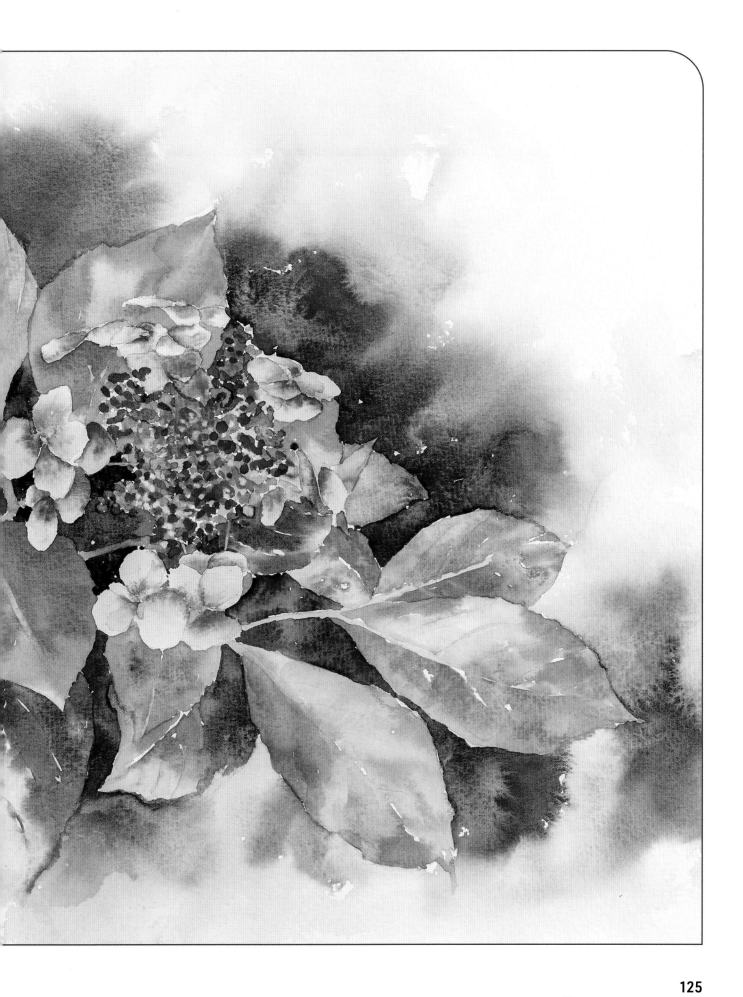

Combining techniques for a different approach

As well as adding more to the composition, you can use slightly different techniques to create a more ambitious version of the project on the previous pages.

Here, I began by applying masking fluid on the veins of the leaves and the lightest section of the flower centre. I then proceeded in the same way as in our project, keeping the leaves quite simple – more complex leaves would fight with the pigment inks for dominance.

While the leaves are kept simple, more detail in the centre of the flower ensures that the painting remains balanced once the ink, which adds more detail, is applied.

The background here is kept very pale so that the colours glow underneath the painting. I used midnight blue with shadow pigment ink, wetting the darker sections between the leaves before dropping in the pigment ink and immediately spritzing the area, allowing the ink to flow over the top of the leaves and background. This may seem like quite a daring thing to do – especially when you have a painting with which you are happy. However, once you practise with the ink, you will find that even a dark section can be very easily lightened by spritzing the surface.

Here, I spritzed heavily and all the fine textures that you see appeared. There are no heavy dark patches and it's all fairly delicate, which gives a real feeling of depth and interest to the painting.

French Hydrangea
35.5 x 52cm (14 x 20½in)

The outline is also available to download free from the Bookmarked Hub: www.bookmarkedhub.com, as described on page 16.

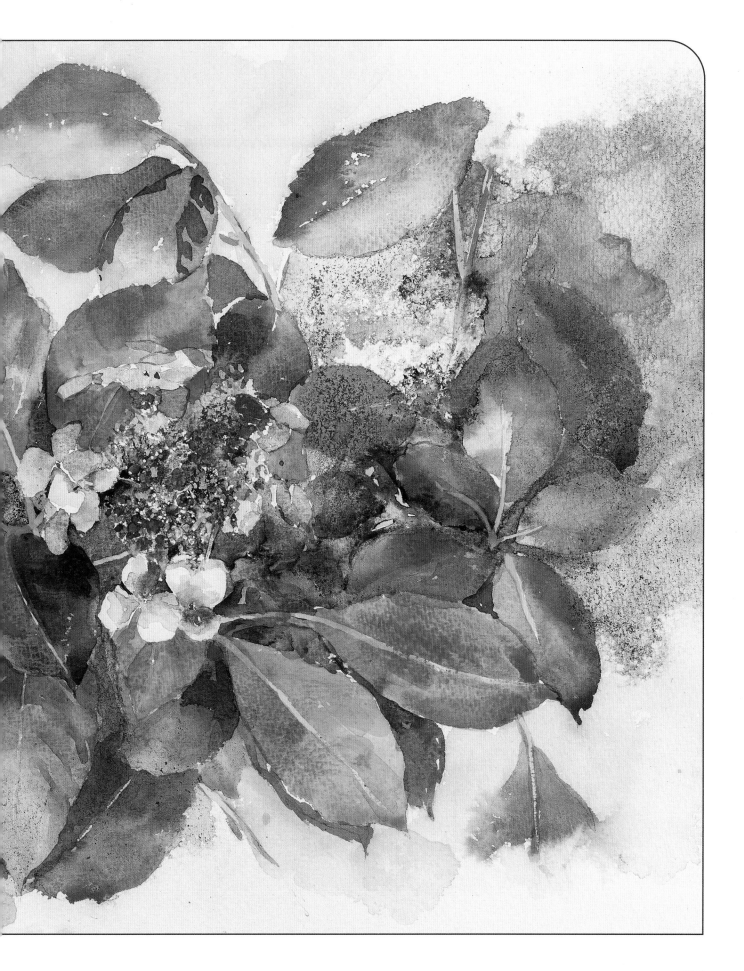

Index

alliums 85
anemones 41, 115
aster(s) 69, 110, 111

background 23, 26, 33, 37, 49, 54, 56, 57, 58, 60, 63, 69, 71, 72, 74, 75, 77, 79, 81, 83, 84, 86, 89, 91, 99, 102, 104, 108, 111, 112, 115, 117, 120, 121, 124, 126
balance 30, 91
berries 13, 29
bookmarks 6, 30
bougainvillea 69
brushes 8, 18, 20, 24, 32, 34, 54, 72, 96, 118

camellias 96, 102, 104
clematis 7
colour combinations 29, 30, 46
colour swatches 29, 30, 38
composition 24, 30, 33, 58, 60, 79, 81, 85, 90, 91, 92, 102, 104, 106, 107, 124, 126
contour drawing 86, 88, 90, 91, 92
cornus 7
cotton bud (q-tip) 13, 29
cow parsley 26, 27

daffodils 5, 34, 92, 93
dark tones, mixing 50
depth 32, 40, 60, 72, 73, 79, 81, 102, 121, 122, 124, 126
dropping in 32, 35, 54, 55, 58, 72, 73, 79, 88, 96, 97, 118, 119

focus 6, 40, 69, 71, 81, 86
foliage 52, 81, 84, 85, 122

granulation 50, 109
grasses 13, 85, 95, 110, 112
greens, mixing 52
greetings cards 13, 25, 26, 27, 29

hellebore(s) 51, 65, 106
hollyhocks 112
hydrangea 118, 120, 124, 126

ink(s) 13, 63, 107, 114, 115, 116, 117, 120, 126
iris 110, 112

lavender 85
lifting out 22, 68
light 13, 40, 42, 45, 48, 74, 83, 84, 86, 91, 94, 96, 99, 102, 110, 119
lilies 63
lily pads 45
loosening up 108

magnolia 72, 78, 81, 83
masking fluid 12, 13, 45, 46, 47, 94, 95, 96, 98, 100, 102, 118, 119, 120, 122, 124, 126
mock orange 54, 58

negative painting 26, 75, 87, 121

outdoors, painting 64, 84, 92
outlines, transferring 13, 17, 25
outlines, using 16

paints 9, 18, 20, 24, 32, 34, 54, 72, 96, 118
 preparing 15, 19, 26, 34, 35, 36, 38, 54, 56, 74, 97, 118, 120
palette knife 63, 107, 110
palette reference 38
petal(s) 18, 19, 20, 21, 34, 35, 36, 41, 48, 49, 64, 65, 72, 73, 74, 76, 77, 81, 94, 96, 97, 98, 100, 102, 104, 110, 112, 116, 118, 119, 124
poppy(-ies) 5
postcards 46

reference 6, 16, 36, 38, 39, 44, 45, 54, 72, 76, 87, 102
rose 42, 48, 49, 65
rudbeckia 95

salt 13, 70, 71, 81
shading/shadows 36, 49, 54, 55, 58, 60, 74, 76, 79, 81
soft edges 36, 55, 63, 64, 72, 96, 99, 118
spattering 108
stamens 8, 40, 47, 56, 58, 75, 96, 112
stem(s) 19, 27, 32, 33, 46, 55, 58, 60, 84, 87, 92, 99, 102, 108, 110
stick, using a 12, 104, 107, 112, 116

sunflower 116, 117
sunlight 26, 45, 48, 53, 73, 74, 76, 77, 98
swatches 29, 30, 38, 39, 42
synthetic paper 10, 11, 17, 18, 20, 22, 23, 34, 47, 68, 69, 84, 88, 94

techniques 5, 6, 7, 8, 11, 13, 22, 23, 58, 63, 64, 76, 79, 83, 102, 104, 109, 111, 118, 119, 124, 126
texture 8, 10, 13, 63, 68, 70, 71, 72, 75, 77, 83, 110, 117, 120, 124, 126
 with the Golden Leaf brush 71
thirsty brush 22, 47, 66, 71
tone 34, 38, 39, 40, 41, 42, 44, 45, 48, 49, 54, 55, 56, 57, 58, 60, 73, 74, 75, 79, 81, 96, 97, 99, 102

tone checkers 44, 45
tone scale 42
tulips 23, 67, 84, 106, 108, 109

underpainting 60
unusual viewpoints 90

watercolour paper 10, 16, 17, 18, 22, 24, 32, 34, 38, 39, 44, 46, 54, 64, 68, 72, 84, 88, 94, 96, 102, 108, 110, 118
wet into wet 20, 33, 35, 56, 104, 114
white flowers 46
 on natural paper 46
 on synthetic paper 47
working outside 84

Yupo see also synthetic paper 4, 5, 10, 11, 18, 19, 20, 22, 34, 37, 68, 69, 84, 93

Outline 20

Simple Flower
9 x 13cm (3½ x 5in)

Try different combinations of colour with the techniques earlier in the book for this simple flower.